GRANTHAM AT WORK

JOHN PINCHBECK

AMBERLEY

ABOUT THE AUTHOR

Grantham-born John Pinchbeck can trace his male line back to the mid-seventeenth century in the town, when his family came from the Spalding area to support Oliver Cromwell.

He became interested in local history leafing through old editions of the *Grantham Journal* while working there.

Firstly, he self-published the *Grantham in the News* series, covering 1851–2000 in six volumes, followed by commissions for *Changing Face of Grantham*, *Grantham in Focus* and *Grantham Through Time*.

He created a website for people to post old photographs. This proved so popular it became GranthamMatters – carrying news and comments as well as the popular Grantham Past section – and now attracts more than 10,000 visitors a day.

Grantham at Work is his fourteenth publication (including two which are heavily revised editions of previous books).

First published 2019

Amberley Publishing
The Hill, Stroud
Gloucestershire, GL5 4EP

www.amberley-books.com

Copyright © John Pinchbeck, 2019

The right of John Pinchbeck to be identified as the Author of this work has been asserted in accordance with the Copyrights, Designs and Patents Act 1988.

ISBN 978 1 4456 7763 7 (print)
ISBN 978 1 4456 7764 4 (ebook)

British Library Cataloguing in Publication Data.
A catalogue record for this book is available from the British Library.

Typesetting by Aura Technology and Software Services, India. Printed in the UK.

CONTENTS

Preface 4

The Early Engineers 5

Working Through the Wars 17

Post-war Engineering 23

Food and Drink 33

Furniture, Footwear and Fashion 41

More Manufacturers 48

Services and Charities 59

What's in Store 73

Other Employment 84

Acknowledgements 96

PREFACE

During medieval times, Grantham made its mark in the wool trade, with merchants still active in the late nineteenth century. It was on the river crossing (Saltersford) between the east coast and the Midlands for transporting salt.

When the River Trent was bridged at Newark in 1168, the Great North Road moved to the east, passing through Grantham. This led to plenty of work for cordwainers and cobblers.

In the eighteenth century, when stagecoaches were in their heyday, Grantham was sixteen hours from London and became a popular stopping point. There was suddenly lots of work in hotels, catering and looking after horses.

The Grantham Canal, which opened in the 1790s, brought coal to the town and delivered barley to Nottingham's maltings by return. This led to an upsurge of maltings in Grantham, which then sent malt to Nottingham breweries.

Agriculture was very busy leading to Richard Hornsby and James Coultas first repairing, then manufacturing, farm machinery from ploughs to threshing machines. Before you knew it, Grantham was the heart of engineering.

This is where *Grantham at Work* starts. Although it covers lots of workplaces, it is not a catalogue. We could not squeeze in every employer – indeed not every employer wanted to be in it – but my thanks for the courtesy of those who co-operated.

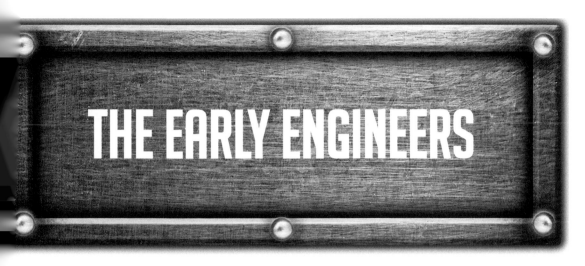

THE EARLY ENGINEERS

RICHARD HORNSBY & SONS, RUSTON AND HORNSBY, ALFRED WISEMAN

Richard Seaman, with his apprentice Richard Hornsby, opened a smithy on the east side of the Great North Road in Spittlegate, an ideal site given the growing stagecoach trade. By 1815 they were partners and in 1828, when Seaman retired, the company became Hornsby's.

The tiny parish of Spittlegate, south of St Catherine's Road, became a boom town, with brick-built factories springing up on both sides of London Road employing more than 500 people while builders worked flat out erecting homes for his ever-increasing band of workers.

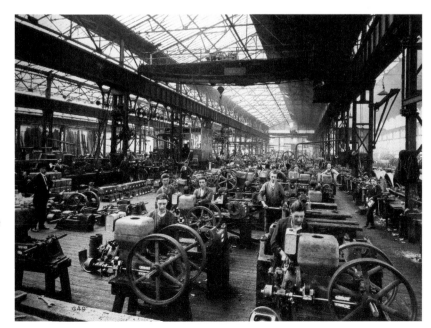

Fitting shop working on horizontal oil engines in 1928 at Ruston and Hornsby.

Looking at agricultural goods, Hornsby saw poorly designed equipment. He modified it and then turned out quality goods, improving both tilling and harvesting across the world.

When he died at the age of seventy-four in 1864, the population of Spittlegate was more than 5,000, compared with less than 500 when he began.

Not only did thousands benefit through jobs he created, but his legacy gave Grantham the reputation of having some of the world's finest engineers.

In 1891 Hornsby's acquired exclusive manufacturing and development rights to an oil-powered engine from inventor Herbert Ackroyd Stuart (amended and patented by Rudolf Diesel five years later). They built the first tractors using oil-burning engines in 1897.

The company agreed in 1899 to cut the working week from fifty-four hours to fifty-three. Men worked from 8 a.m. to 5.30 p.m. with an hour's lunch each weekday and from 7.30 a.m. to noon on Saturdays.

In 1911 the company expanded to Houghton Road on land belonging to the Earl of Dysart, employing 2,200.

Lack of marketing expertise seems to have been the ultimate downfall of this innovative company, despite brilliant developments including the first practical continuous track system for vehicles by works manager David Roberts. The rights were sold to US company Caterpillar, and later developed by Fosters of Lincoln for the tank initially used in the First World War.

With the help of war department contracts, the payroll had risen still further to 3,000. However, the company was not trading profitably so in 1919 it was taken over by Lincoln company Ruston, Proctor & Co. to become Ruston & Hornsby.

Manufacture of agricultural implements ended at Grantham in 1937 to concentrate on making engines, boilers and pumps.

By 1950 it concentrated on the production of oil engines, of which **98** per cent were exported. The company was booming with over-subscribed order books in 1953. However, 1958 saw the beginning of the end when the foundry closed and work transferred to Lincoln.

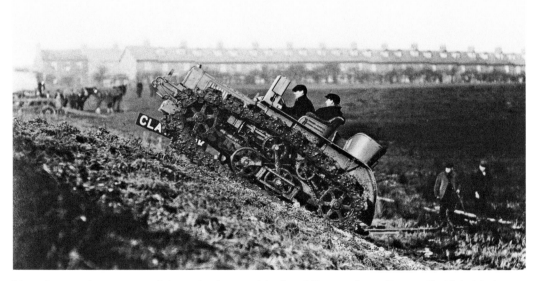

Hornsby crawler tractor trials on land owned by Lord Dysart (later Dysart Park) behind Houghton Road, 1908.

Ruston and Hornsby's top foundry, Spring Gardens, in 1926. Men working in these terrible conditions were said to age prematurely.

Then, in 1963, the name, which had dominated Grantham industry for 130 years, disappeared when R&H moved oil engine manufacture to Lincoln and subsidiary Alfred Wiseman moved to Grantham where engineers were employed in gear cutting and assembling gearboxes.

Three years later it was taken over by English Electric in a £24 million deal. In 1968, the remaining 400 workers were told the grim news that the Grantham works was to close.

In 1973 the Spring Gardens foundry was demolished to make way for a car showroom and eighteen years later the main factory came down following a £100,000 bid put together by local businessmen.

MFI and B&Q were built in its place, together with a number of smaller businesses.

AVELING-BARFORD, WORDSWORTH HOLDINGS

Aveling-Barford was a giant engineering force in the town. The name was created from Aveling & Porter, inventors of the steamroller, and Barford & Perkins. Edward Barford had bought both companies from the receiver with financial help from Ruston and Hornsby of Grantham.

In return, Ruston's insisted the new company, Rochester-based Aveling-Barford, move to its redundant Houghton Road factory and buy Hornsby-produced engines, forgings and castings.

Barfords, as it was known, opened in December 1933, and within a year Grantham's unemployment figure fell from 2,350 to around 1,600.

The company sought new products and developed a small dumper. Post-war, the company developed a new breed of road rollers, powered by diesel engines, and spearheaded a worldwide export drive, chartering whole trains to take its goods to the docks. A large earth grader was added to the list of products and the size of dumpers continued to grow eventually to 40-ton giants.

Calfdozers – small bulldozers – plus trench cutters and concrete finishers were added as the company became the town's biggest employer with a workforce of more than 3,000.

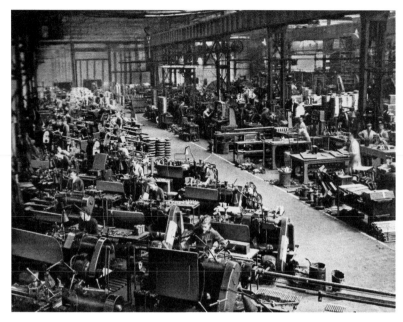

The light
machine shop at
Aveling-Barford's
Houghton Road
works in 1939.
On the right
is part of one
of the heavier
machine shops.

The last SN-type
Dumper made by
Aveling-Barford in
1975 is destined
for the Aswan
Dam project in
Egypt. The staff
involved were
treated to
champagne to
celebrate.

The beginning of the end came in 1967 when Barford's were involved in a shotgun merger with Leyland Motor Corporation. Leyland itself had staggered from crisis to crisis until it was nationalised in 1975.

The Grantham works was a small cog in the BL machine and by 1980 a lack of investment and excruciating overheads left it in a precarious state. In 1981 a titanic 85-ton dumper was built, but design faults prevented it going into production.

By 1983, when the firm was bought by Singapore rubber tycoon Dr Lee Kin Tat, there were only 800 employees and turnover had dropped to £30 million, around half of what it had been a decade earlier.

In June 1988 the receivers put the company out of its misery, and the 550 working there joined the dole queue. Unable to sell it as a going concern, due to £40 million debts, the receivers sold the assets to Wordsworth Holdings, which in turn was dissolved in 2010.

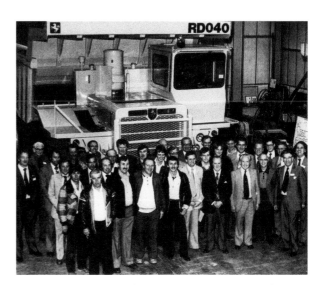

RD040 Dumper made by
Aveling-Barford in 1975.

BMARCo

The fifty-four-year history munitions maker BMARCo (British Manufacturing and Research Company) began in January 1938, a collaboration of Hispano-Suiza and the UK government.

BMARCo (later Astra) from the air in 1988. Springfield House (later Totemic) is at the top and Walton Gardens is on the far right.

Britain needed its own supply of cannon for aircraft, so the purpose-designed factory was built on Springfield Road.

During the war the local workforce was increased by staff from neighbouring towns and Polish refugees swelled to a peak of 7,000. They produced 100,000 cannon and 60 million rounds of ammunition for the likes of the Hurricane and Spitfire aircraft. At the end of the war the number of staff fell to 500 and many workshops were leased to other companies.

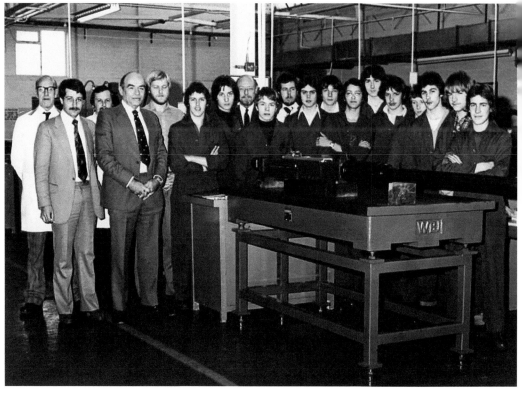

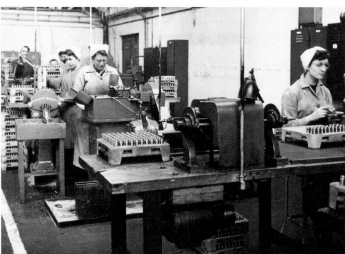

Above: BMARCo apprentices in 1982 with some members of management.

Left: Women at BMARCo's Springfield Road factory making shells in around 1962.

BMARCo struggled in early peacetime, making washing machine parts, turbine blades and camshafts for the motor industry.

The first decent arms contract came from India in 1952 followed by a Syrian order for reconditioned guns. Then a bumper order for armoured vehicles from West Germany put the munitions maker back on track.

In 1971, Oerlikon Buhrle took over and its investment saw a change of fortunes. The workforce leapt to 1,153 within six years, concentrating on munitions.

There was a major scandal in 1982 when it was discovered that the company was supplying both the UK and Argentina in the Falklands War. Then in the late 1980s its products found their way past sanctions to the Middle East via Singapore.

The company was bought in 1988 by Astra Holdings but after four years BMARCo was in the hands of the receivers and closed in 1993.

WILLIAM H. ASTBURY

When William H. Astbury's Atlas Works, on Wharf Road, opened in February 1881, it went from strength to strength. The company, which manufactured screw-cutting lathes and engineering machine tools, also built a horizontal boring machine at Spittlegate Ironworks. The company later moved to Nottingham.

POTTERS PUMPS

In 1920, Phoenix Works, on Dysart Road, was taken over by A. C. Potter of London. These well-boring and pumping specialists moved its complete operation to Grantham, but Potters Pumps failed to survive the slump of the 1930s, leaving the building empty.

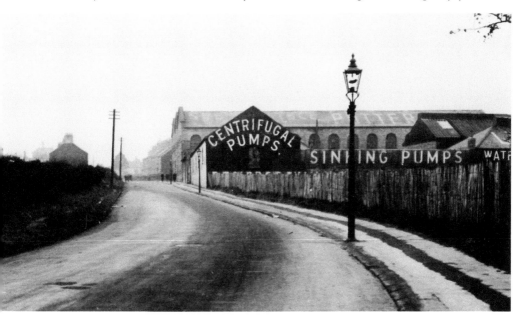

Dysart Road showing Potters Pumps factory (later occupied by R. H. Neal/Coles Cranes).

R. H. NEAL, COLES CRANES

Crane making came to Grantham in 1937 when R. H. Neal of Ealing, London, bought the old Potter Pumps factory for £3,000. Specialising in mobile cranes of all sizes, in 1948 they celebrated a six-figure contract to supply sixty cranes to Poland, which guaranteed a year of full-time employment for its 300 workers.

Two years later it built the biggest travelling crane in the country. The £8,000 machine could move with a top load of 10 tons.

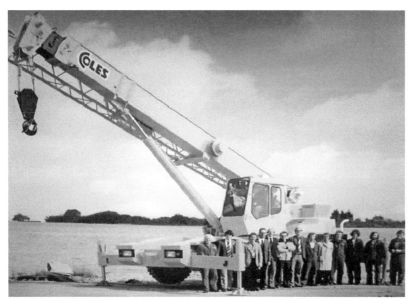

Coles Cranes taken in 1978.

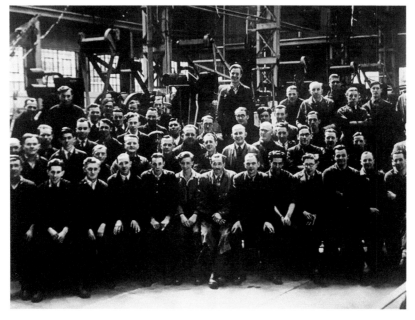

Some of the workforce at Neals Cranes, Dysart Road, 1956.

Coles Cranes held an open day at its Dysart Road works in May 1975.

In 1964 it became part of British Crane Corporation and changed its name to Coles.

A £500,000 massive facelift and extension scheme to meet booming export demands came in 1973. Eleven years later liquidators Cork Gully announced its closure with the loss of 136 jobs and production transferred to Sunderland.

The following year town businessmen Allan Burrows and David Eatch bought the site, turning it into the 20-acre industrial and commercial estate Autumn Park.

JAMES COULTAS

Twenty-year-old James Coultas started his own ironworks alongside the Mowbeck in Union Street in 1808. By 1826 he was making horseshoes, prize-winning seed drills, general agricultural implements of iron and added a brass foundry. His son, also James, took over and showed his wares at the Great Exhibition of 1851, where Queen Victoria bought his agricultural equipment for the royal farms at Bagshot.

In 1862 James the younger leased land bounded by Grantley Street, Wharf Road and Station Road. He built the Perseverance Ironworks, supplying wood from his own timber company. He installed forges and foundries for iron and brass, as well as producing cast, wrought and moulded metal.

The foundry also made much of the town's street furniture including boundary posts, channel and manhole covers (some of them still in use). Meanwhile, John Coultas continued in Union Street.

The Perseverance Ironworks was sold in November 1955, with all engineering and woodworking machinery offered without reserve. The wood and timber side became English Bros in 1967 and later Jewson.

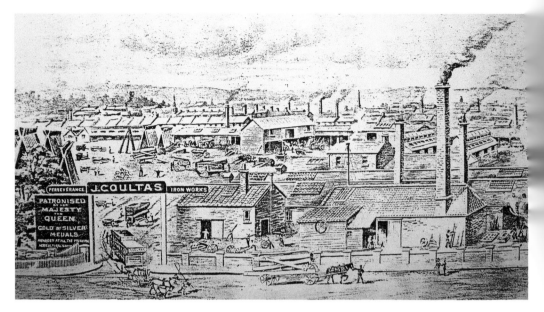

Above: A fanciful drawing of James Coultas's factory, Station Road West.

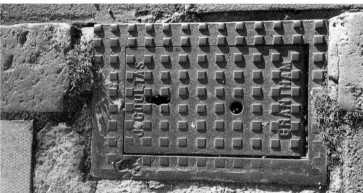

Left: Grating on St Peter's Hill cast by James Coultas.

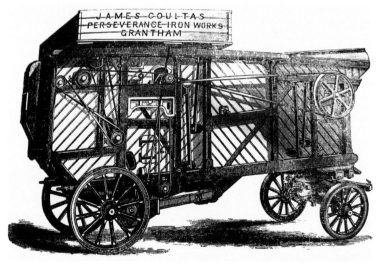

Threshing machine made by Coultas of Grantham, 1860.

HEMPSTEADS, GRANTHAM BOILER AND CRANK

Brothers George and Nathaniel Hempstead already had one engineering works that they had built in the 1840s (where Matalan stands). They built the Phoenix Ironworks on the north side of Dysart Road in the 1870s, but within ten years it closed and was left to rot until 1920.

Their old works was renamed Grantham Crank and Iron Co., which from 1905 became Grantham Boiler and Crank Co.

Grantham Boiler and Crank produced a mass of engineering products ranging from boilers and crankshaft forgings to bridges. The company closed in 1956, putting its last thirty employees out of work.

Managing director J. L. Coltman blamed the shortage of materials due to the national steel strike, saying it had a full order book including a contract to supply boilers for the Russian fishing fleet.

The biggest boiler ever made in Grantham was completed by Hempstead and Co. in 1876. It weighed more than 14 tons and needed sixteen horses to transport it to Nottingham.

A portable boiler made by Grantham Boiler & Crank company in 1901.

EDWARD MORLEY

Edward Morley's site is now a builders merchants, close to Harlaxton Road railway bridge. Until 1932 small pumps and boilers for ploughing machines were made there by the engineering firm.

The company had begun in 1880 as Agnis & Yates, later become Henry Yates, then Yates and Morley, all making steam ploughs. It was later taken over by Jack Harris as Midland Builders Merchants and now operates as Travis Perkins.

RICHARD BOYALL'S CARRIAGE AND STEAM WHEEL WORKS

Richard Boyall's stood on the corner of Station Road and Wharf Road from around 1860 until 1880 when it closed following Mr Boyall's bankruptcy.

Boyall's produced an extensive range of high-quality carriages, artillery wheels and cart components. Little remains of the original works save for the showroom, which has been restored as Jewson's offices and trade centre.

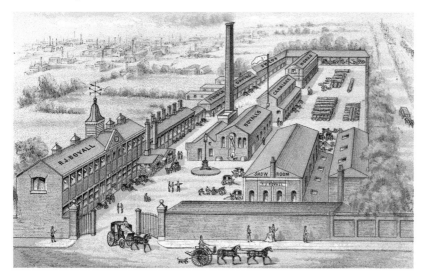

Boyall's factory, Wharf Road, in 1872.

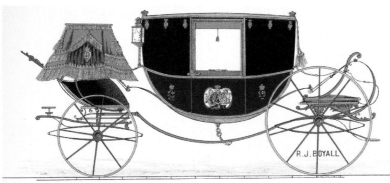

Full Dress Sheriff's Coach.
ESTIMATES GIVEN FOR ALL APPOINTMENTS

Sheriff's coach made by Boyall's of Grantham.

WORKING THROUGH THE WARS

BMARCo

Sixteen workers were killed and thirty injured in an air raid on the Ministry of Aircraft Production (BMARCo) factory, Springfield Road. The sirens sounded at around 2 p.m. on 27 January 1941 as a Junker Ju88 crossed the town towards BMARCo.

A secret agent based in the town had informed German High Command that the Grantham factory was the sole UK manufacturer of the Hispano Suiza aircraft 20 mm cannon – a vital weapon in the air.

Home Guard machine gunners on the factory roof fired into the low cloud where they heard, but could not see, the aircraft, which had circled the factory. It dropped four bombs on the factory as the gunners opened fire, then disappeared over Hall's Hill with one engine blazing.

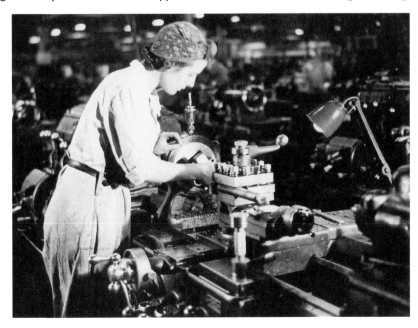

Woman machinist at BMARCo in 1941.

The first bomb landed near Buckminster Gardens, leaving eighty-eight people homeless. The second struck the joiners shop, rolling under a bench and failing to explode. A third hit the factory, causing extensive damage, and the fourth hit an air-raid shelter, killing two workers.

The pilot of the Luftwaffe plane, Oberleutnant Freidrich Rinck, had selected BMARCo as his target to celebrate his 100th mission. The Junkers crashed near Boston and the crew were captured.

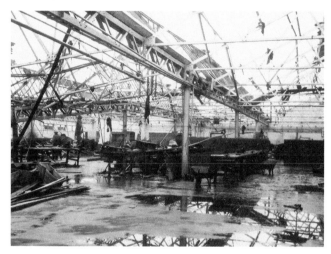 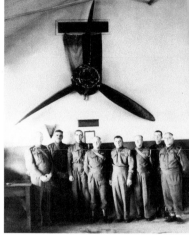

Above left: The BMARCo factory, Springfield Road, was hit by a bomb in 1941.

Above right: The prop of the Junkers shot down by BMARCo Home Guard in 1941. It remained in the social club hall until it was pulled down in the 1980s and sold for scrap.

Below: BMARCo munitions workers in 1945.

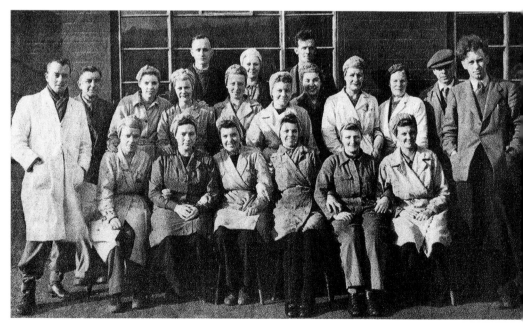

RUSTON AND HORNSBY

During the First World War, Richard Hornsby & Sons continued to concentrate on agricultural machinery as well as engines used by the armed forces. They also erected the prefabricated huts for the military at Belton Camp. Due to the younger men joining the Army, female workers were employed for the first time.

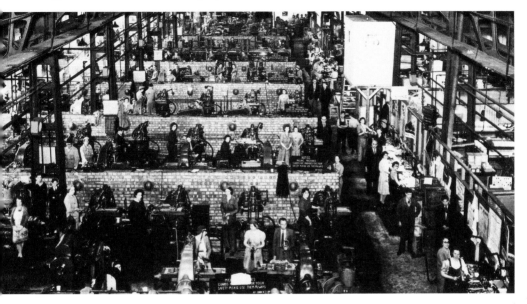

Ministry of Aircraft Production, on London Road in 1942, who had taken over part of Ruston and Hornsby for the war, making Oerlikon gun magazines. The blast walls between the sections were to protect the workers should their factory be bombed. The helmets were hung on them, and failure to wear them could lead to disciplinary action at best – and at worst a graver result. And, of course, a high proportion of the workforce were women.

Ruston and Hornsby's factory, on the east side of London Road, took a direct hit in 1940.

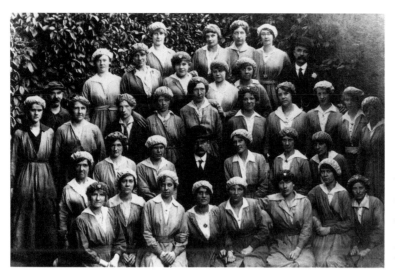

Women took over men's jobs at Richard Hornsby & Sons during the First World War.

In the Second World War, Ruston and Hornsby built Bren gun carriers, although part of the works was taken over by the Ministry of Aircraft Production and Sullivans, which produced coal-mining equipment. Again, more women were employed.

Like BMARCo, it took several hits from bombers and was the target in September 1940, leaving seven dead and sixteen injured.

SULLIVANS

For ten years, including the whole of the Second World War, this small firm was at the forefront of the war effort in pioneering the mechanisation of British mining at the coalface.

The Sullivan Machinery Company, a leading name in US coal mining machinery, began part-manufacture at Letchworth in the mid-1930s, but soon outgrew available space so in 1936, with support of the town council, they moved up to Grantham. Their new home was on the ground floor of one of Ruston and Hornsby's workshop bays along the west side of London Road.

At the end of the war, Ruston and Hornsby too had plans for the future and wanted the return of their workshops and offices leased to Sullivans, so in 1947 Sullivans moved its facilities and many of its staff to Shrewsbury.

R. H. NEAL

Like so many companies, Neal's crane works fell under the control of the Ministry of Supply. While continuing to build cranes, they were for the military and not the commercial market.

AVELING-BARFORD

When the Second World War broke out, much of Aveling-Barford's production switched to armaments. The Scout Bren gun and personnel carriers were the main ones. Production eventually reached a peak of sixty per week.

Testing a Bren gun carrier at Aveling-Barford in 1940.

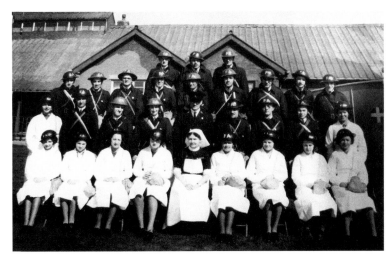

Aveling-Barford ARP first-aid section in 1944.

Thompson's maltings, Bridge End Road, taken in 1917, where women had taken over while the men were at war.

As well as Bren gun carriers, the company produced large quantities of shell fuse caps and undertook the precision machining of various components including submarine engine cylinder heads and tank turrets.

The company's war effort was not, however, confined to the production of munitions. Rollers and dumpers were still needed for aerodrome and road construction both at home and at the fighting fronts.

There were two air raids on Aveling-Barford, both without casualties.

BUILDING

In wartime most of the building was for the war effort, with few domestic houses built.

During the First World War Belton training camp had to accommodate 20,000 troops, so the timber buildings were erected by local engineers, mainly from Richard Hornsby & Co.

During the Second World War, again most of the building was for industry. One exception was Beeden Park, built in the early 1940s when air raids were common in the town. The homes were of modern design, with flat roofs, and the first completed were for workers associated with the war effort. They were built by Hustwayte of Nottingham for £128,487.

Known as both the 'Flat Tops' and 'Garden City', the estate was officially called Beeden Park after Alderman Harry Beeden.

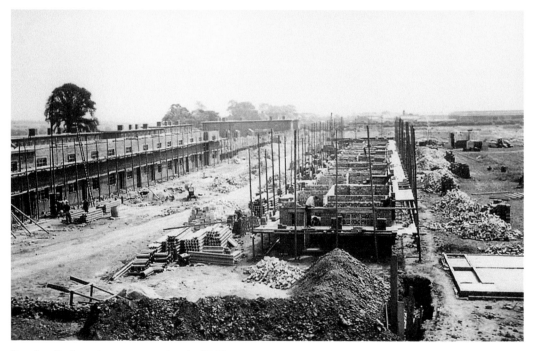

Beeden Park under construction in 1940.

POST-WAR ENGINEERING

GRANTHAM PRODUCTIONS

Denis Kendall was production manager at Citroen in Paris for nine years before moving across the city to the munitions arm of motor manufacturers Hispano Suiza. He was brought in by Lord Brownlow to create and sustain Grantham munitions factory BMARCo.

When the war ended, he set up Grantham Productions and tried to produce the £100 people's Kendall Car, but managed only four prototypes. His planned motorcycle was also a disaster. It cost him thousands, and his main backer, the Maharajah of Nawanaga, lost an estimated £300,000. His Kendall Tractor fared a little better and was eventually taken over by Newman Tractors.

He also published short-lived newspaper the *Grantham Guardian* in the late 1940s.

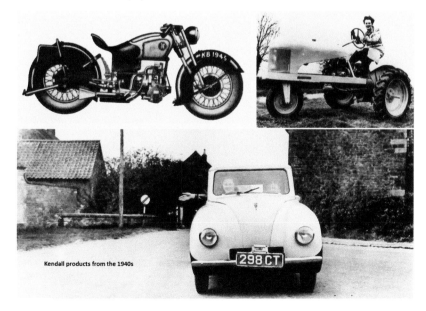

Kendall products from the 1940s

Products of Denis Kendall's Grantham Productions in 1947.

STEELWELD

Detroit engineers Ken Burmaster and George Botelho opened Steelweld in 1959 on part of the BMARCo site. It employed many of the engineers BMARCo was struggling to find work for.

Steelweld made tools, especially multi-welding plants, for the worldwide motor manufacturing industry using American technology.

After completing the Ford Cortina underbody line, in 1971, Steelweld won a £700,000 order to supply two fully automated press welding lines to the USSR.

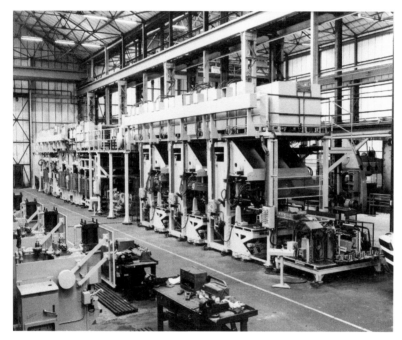

Left: Multiweld and Hemming lines for truck door assemblies made by Steelweld for the Gorki truck plant, USSR (Russia), in 1971.

Below: Vibratory motor winding section at Steelweld in 1968.

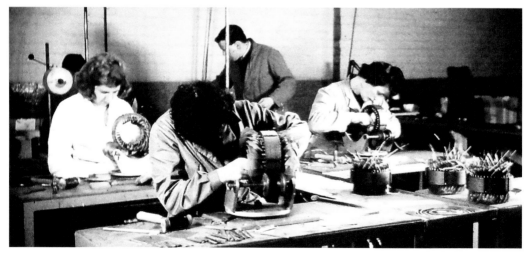

In 1972 the Springfield Road factory closed with the loss of seventy jobs and work transferred to Breda in Holland.

At its peak 350 people worked there.

BGB ENGINEERING

BGB was established in 1976 as a manufacturer of carbon brush holders and began exporting in the early 1990s.

Founded by David T. Holt from his garage in Leicestershire, the company soon progressed into a multinational manufacturing plant, selling rotary solutions and underwater lighting products to market leaders in renewable energy, rotary door, wastewater and aquaculture from its four-time extended factory on Dysart Road, with an R&D centre at Turnpike Close.

In 2004 BGB purchased the commercial interests of another Grantham company – Aquabeam Ltd, manufacturers of aquaculture products. This expanded the company's product portfolio into the field of underwater lighting, camera systems and cables/connectors.

In 2012, BGB Technology was formed to extend to the US market, based in Richmond, Virginia. BGB SILS (Submersible Inductive Lighting System) was created in 2014 as a luxury brand dedicated for the yachting and boat market for induction lighting systems in Grantham and a sister manufacturing site at Richmond, USA.

In 2017 over 120 people were based in Grantham, with a further thirty in the US.

Since 2013, BGB have exported to over fifty-five countries worldwide, sold over 340,000 slip ring units with over 1,200 different slip ring variants. BGB products are installed in over 65,000 wind turbines around the globe, powering over 1 million homes.

BGB have provided power to over 2,600 rotary doors and are the first European slip ring manufacturer to create its own web shop. BGB SILS is the first ever colour-changing contactless underwater lights for the luxury yacht market.

GRANTHAM ENGINEERING, GRANTHAM ELECTRICAL, MOGENSEN INVICTA VIBRATORS

One of the town's oldest manufacturing companies, Grantham Engineering was formed in 1946 by Sidney Pask. Employed by Aveling-Barford during the war, he began his company with the help of his wife, Monica.

At first he concentrated mainly on electrical contracting, industrial rewinding and auto electrics repairs. He also established an outlet selling domestic electrical goods. He began in Watergate, a building demolished to make way for a supermarket, later expanding into premises behind the Black Dog pub.

In 1957/8 the company saw the chance to introduce a new range of vibrator motors into the UK. Further factory space was needed and the old school in Welby Street was taken over.

In 1960 Mr Pask sold the company to Aveling-Barford but remained managing director and two years later entered the vibratory equipment field, now the main product.

In the late 1960s Aveling-Barford merged into British Leyland. Then in 1972 Grantham Electrical was taken over by Pask and Colin Ryan of Aveling-Barford, becoming a private company.

Exports developed rapidly from almost none in 1972 to around 20 per cent of turnover in 1976. It now stands at more than 80 per cent of production.

Having established the vibrator side of the business Grantham Engineering followed up by designing and marketing its own vibratory screens, feeders, conveyors and grizzlies. This led in 1987 to the acquisition of Mogensen Sizers and the consolidation into one wide range of machines marketed under the Mogensen brand.

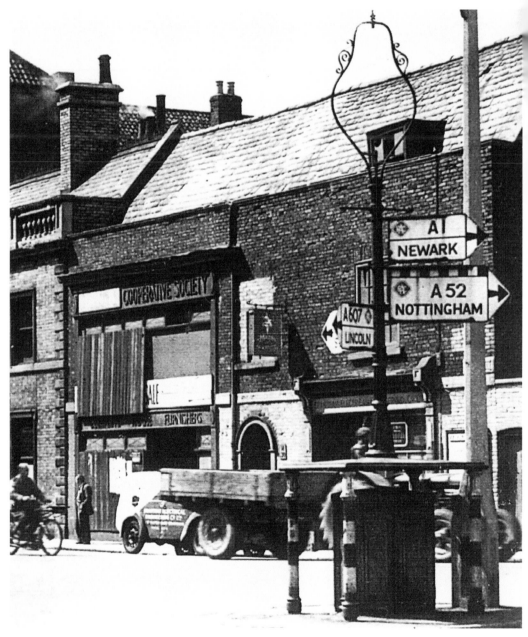

Grantham Electrical in 1947. This image shows the outside of its first depot in Watergate.

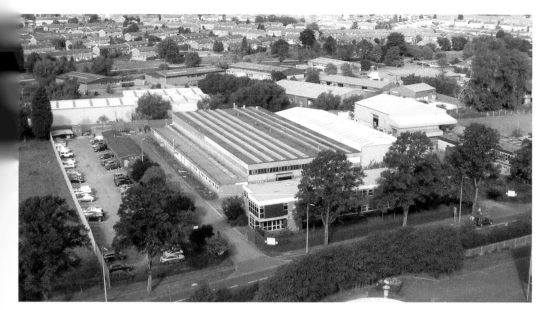

Grantham Electrical Engineering in 2009.

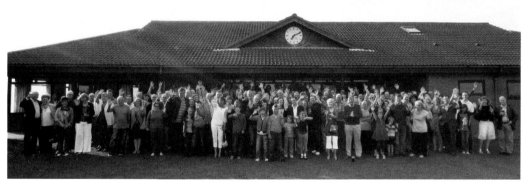

Employees of Grantham Engineering and their families celebrate the company's sixty-fifth birthday at Grantham Cricket Ground, Gorse Lane, in 2011.

The range of vibrator equipment also increased to cover motors, feeders, compaction tables, screens, tubular conveyors and beams and are even used in South African gold and diamond mines, as well as haunted houses in funfairs.

The company, which employs over 130, is concentrated at Harlaxton Road.

FARM ELECTRONICS

Farm Electronics was founded by Nick Chandler near his home in Welby in 1968. It specialises in cooling and ventilation systems for crop storage such as potatoes and onions. The company moved to new premises on Alma Park in 1991 and has remained there.

Farm Electronics in 2019.

Although essentially working for the UK market, their systems can be found in New Zealand and Egypt, as well as across Europe.

In June 2016, Dutch company Tolsma-Grisnich acquired a controlling interest and in 2019 took it over entirely. It has a workforce of fifteen.

RANSOME & MARLES

Ransome and Marles took over part of the former Ministry of Aircraft Production site, Springfield Road, at the end of the Second World War, manufacturing bearings. It created 300 jobs, half of them for women. It closed in 1957, putting eighty out of work. Other staff were transferred to the Newark factory.

NEWMAN'S TRACTORS

Grantham Productions' ill-fated tractor manufacturing was taken over by Newman's of Yate, near Bristol. The company lasted in Grantham for around ten years, shutting in 1958 and shedding 100 jobs. A lack of skilled labour in the Grantham area was blamed for its demise.

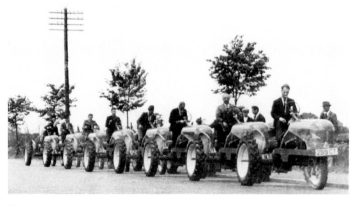

Newman Tractors before moving to Gloucestershire in 1948.

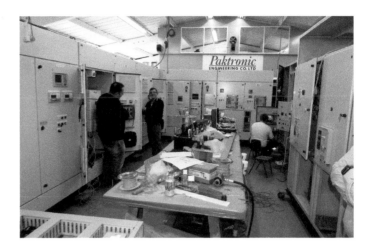

Paktronic Engineering, 2019.

PAKTRONIC ENGINEERING

Paktronic Engineering was set up by three electronic engineers working for PERA of Melton Mowbray in a former chicken shed. They moved to a workshop in Cambridge Street, Grantham, in around 1957, building electrical control panels after receiving a major order from a Leicester Knitwear company.

In 1965 they moved to their current custom-built home on Alma Park. Now the thirty-five employees not only do the electrical work, but build and spray the metal panels in their workshop.

Anglian Water is probably their biggest customer, but their products are found worldwide including in Trinidad and Tobago and on North Sea oil rigs.

CADDY CASTINGS

Caddy Castings, which operated on the site of the old brick kiln, on Springfield Road, was formed in 1896. Its original foundries were at Daybrook and Watnall, Nottinghamshire, but moved to Grantham in 1960.

The company produced non-ferrous castings weighing up to 1 ton. These included casings for electric motors, pumps, rollers and gearboxes. In 2012 it was taken over by Kilner & Hutchinson, wound up in 2016 and the factory pulled down almost unnoticed.

The picture shows Arthur Wheeler pouring the molten metal from a witch's cauldron into a mould at Caddy Castings foundry in 1996.

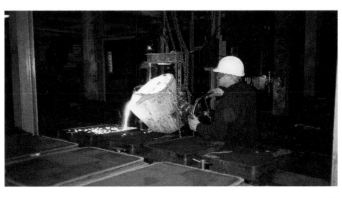

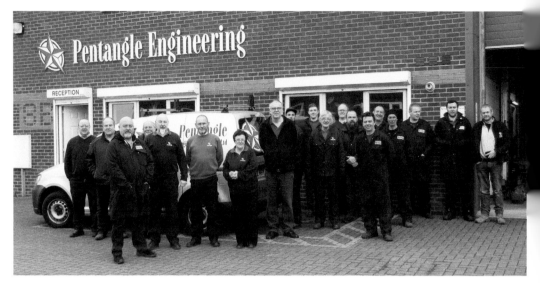

Staff at Pentangle Engineering, Alma Park, in 2019.

PENTANGLE

It all began in June 2004 when three employees at M+T Welding, fearing for their future, set up their own company, specialising in robotics.

Nigel Rivers, Mark Paterson and Andrew Kennedy began by working from home, then within a year opened their own workshop on Withambrook industrial estate. They soon outgrew this and added the adjacent workshop. By 2007 they needed to improve their profile and sank their pension funds into larger premises on nearby Alma Park. They have since taken on the three adjacent buildings.

Their main product is robotic systems and machines used mainly by car manufacturers including Nissan and JLR, especially for welding or handling. They now have a workforce of twenty-seven including apprentices.

POBJOY ENGINEERING, KONTAK MANUFACTURING AND PARKER HANNIFIN

Kontak was founded in February 1947 under the name Pobjoy Engineering. Its plan was to create a labour force on sub-contract work to eventually lay down an assembly line for a light tractor. In the meantime it made zip fasteners.

The following year, before this materialised, Mr Pobjoy was killed in an air crash, resulting in reorganisation and the company's name changed to Kontak Manufacturing Co. Ltd.

The company leased a wartime shadow factory on Londonthorpe Lane. An early contract was the supply of spare parts to the Royal Ordnance Depot at Chilwell to repair American vehicles used and operated by the British forces. The contract lasted until 1952 when Kontak began to produce a progressive variable ram for the Rolls-Royce Avon engines, together with a high precision fuel governor pump and a viscosity

compensating device. This contract firmly established the company in the aircraft and precision engineering field.

During the 1960s Kontak saw the company's skills were applicable to a wider range of industrial and hydraulic products and diversified. It took over Rubery Owen Hydraulics, giving them the most comprehensive range of any valve manufacture in the world.

Above: Kontak's factory, originally a wartime shadow factory, in 1956.

Below: Kontak's 1981 picket line objecting to new bonus scheme.

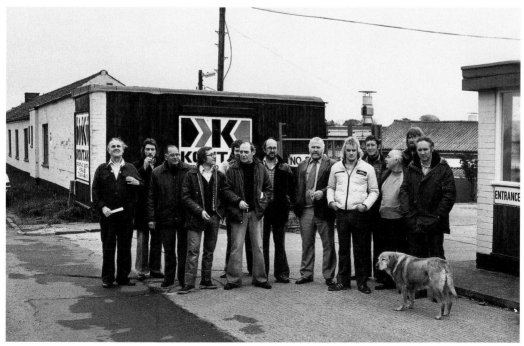

The collapse of aircraft engine maker Rolls-Royce in 1971 led to short time and thirty-seven employees in the aircraft section were made redundant while 150 of the remaining 200 were put on a three-day week.

However, by 1975 Kontak order books were so full that they agreed to take over a modern factory on the site of the former Bjorlow tannery, making way for sixty more jobs.

Development at the Londonthorpe Lane works was set to continue, adding a further 140 to the payroll. Three years later a £500,000 investment created another forty jobs.

It became Parker Hannifin following a takeover in 2000. Covering 60,000 square feet, the site now employs around ninety people.

Above: Parker Hannifin factory, 2019.

Left: Inside the Parker Hannifin factory, 2019.

FOOD AND DRINK

FENLAND FOODS

The £8 million Fenland Foods factory, Swingbridge Road, was completed by Christmas 1986 and began production in the new year. More than 200 hopefuls applied for a supervisor's job.

Around 150 people were employed at the opening of the plant, making Italian ready meals for Marks & Spencer, as well as the four biggest supermarket chains. By 2008 it reached 738 employees, before the shock news it was to be mothballed by its owners, Northern Foods, following a breakdown in talks with M&S over prices for a new contract.

Four years passed before it was decided not to reopen, so equipment was transferred to other factories and the site put up for sale. At the time of writing it remains closed.

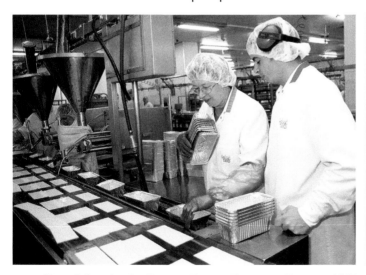

Above left and right: Fenland Foods, Turnpike Close, in 2002.

HAWKENS GINGERBREAD

Opening at the former Salvation Army Citadel, London Road, in 2016, Hawkens Gingerbread may be one of the newest companies to feature in this book, but it makes the oldest product.

During the old coaching days, Grantham was one of the stopping places and while the horses were being changed nearby, passengers would purchase a supply of Grantham Whetstones – a form of (very chewy) biscuits.

Then, in 1740, Butchers Row baker William Egglestone went into his shop one Sunday morning to procure ingredients to make cakes. In the gloomy shop he mistook an ingredient for another, and after baking he discovered his mistake as they rose up and almost doubled in size.

His family liked them, so he made more and offered them for sale in his High Street shop, calling them Grantham Gingerbreads.

Travellers bought them readily, and soon they replaced the tasteless Whetstones, as their fame spread north and south on the Great North Road.

Mr Egglestone eventually sold his recipe to Merchant Briggs, who passed it on to his daughters, who in turn passed it to their nephew R. S. Bestwick, and his successors, Catlin Bros, who opened a café in 1904.

Trading under the same name, Harry Hallam Snr and his family became the next sole makers of the original Grantham Gingerbread.

After Catlins closed the bakery, the Grantham Gingerbread was made solely by a Long Eaton company. Then along came Alistair Hawken, his wife, and one employee and the Gingerbread, now available in a number of flavours, was reborn.

They tickle the tastebuds across the UK, stocked by major supermarkets with the National Trust among its customers.

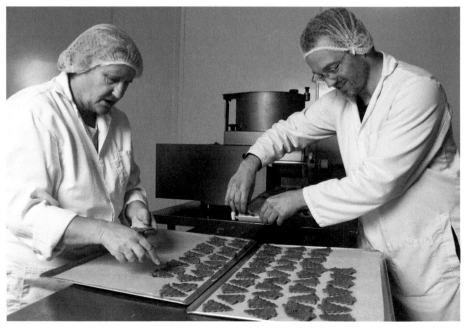

Alistair Hawken and Pauline at Hawkens Gingerbread, London Road. (Neil Lamont Photogaphy, 2018)

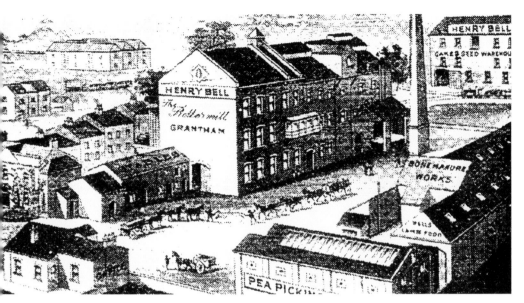

Henry Bell at the Old Wharf in 1898.

HENRY BELL & CO.

Henry Bell & Co. dates from 1825, yet it has long shed its original trade of flour milling. The company now concentrates on milling cereals for pet food. Although it doesn't sell under its own name, its pet food and wild bird seed can be found across the UK and worldwide under other company brands.

It was taken over by John Lee & Son in 1927 when businessman Rothwell Lee was in charge. In the 1960s the flour mills were sold to the Rank Organisation and closed.

Bell's moved to Dysart Road in 1970 where it employs a workforce of around 70 at the Dysart Road mill.

BAIRDS MALTINGS

Bairds Malt, Springfield Road, is the last working maltings in the once traditional malsting town. Dominating the western approach, the 150-foot silo can hold up to 5,000 tons of malt and 1,200 tons of barley at a time. It is made up of thirty-four malt bins and five barley bins.

The plant produces around 30,000 tons of malt a year mostly for traditional UK brewers, although a small amount is used in the manufacture of whisky and even Horlicks. The malt is also exported to North America, New Zealand, Singapore, the Caribbean and Japan.

Working 24/7, the fully computerised plant has only four malsters, each working a twelve-hour shift, plus a dozen other staff.

Originally built in 1964 by Lee & Grinling, it has also operated as R. W. Paul, Pauls & Sandars, Pauls Malt and Moray Firth.

Staircase inside Bairds maltings.

PADLEYS/MOY PARK

Padley's was founded in the 1950s by the late George W. Padley in his home village of Anwick, near Sleaford. He supplied locally bred chickens to national wholesale markets and soon earned a reputation for quality and innovation. The company took over the former knitwear factory at Gonerby Hill Foot in the early 1980s and extended it.

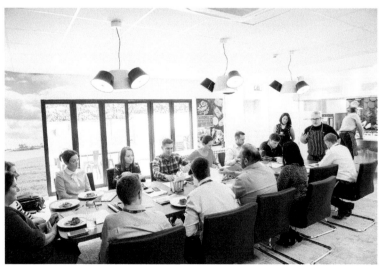

Moy Park's development kitchen, chef's galley and testing areas with group executive chef Aaron Dixon talking to a group of colleagues. (Chris Vaughan Photography, 2018)

In 2004, Padleys was taken over by Moy Park, who three years later were acquired by US-based Pilgrim's Pride Corporation.

Grantham produces ready-to-eat products including cooked whole birds, marinated chicken, snacking products, cooked sliced meats, coated products including nuggets and goujons, chicken Kievs, steaks and patties,

It is one of the town's biggest employers, with around 800 staff.

Above and below: Inside Moy Park, Gonerby Hill Foot.

MOWBRAY'S BREWERY

Malster Samuel Mowbray began brewing in Westbourne Place, off Dysart Road, in around 1828 and soon moved to a site off London Road, which became known as Brewery Hill. In 1842 the firm was known as Mowbray, Robertson & Burbidge.

Twenty years later, Redhead's Spittlegate Brewery was built on London Road, backing on to Mowbray's. In 1891 Mowbray bought out Redhead including a number of licensed houses and fourteen years later John Dawber's Lincoln brewery for £66,475, including fifty-two public houses in the Lincoln area.

In 1952 the company merged with J. W. Green of Luton, which controlled 687 licensed premises. Mowbray had 204 pubs at the time. Two years later Greens was taken over by Flowers, owned by Whitbreads, and brewing ended in Grantham.

The premises were used as a distribution depot until closing in 1967, with the loss of thirty-six jobs, as work was transferred to Luton.

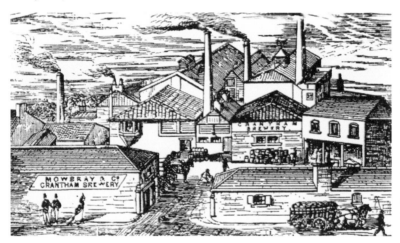

Left: Mowbrays Brewery, from London Road, in 1881.

Below: Mowbrays Brewery staff outing to Scarborough in 1933.

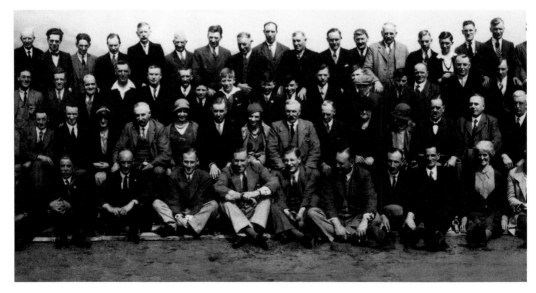

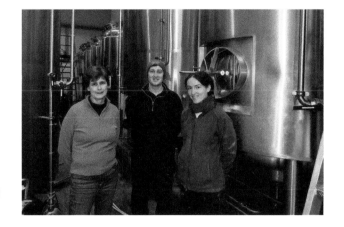

Brewsters of Burnside industrial estate, Grantham, in 2019. Shown, from the left, are brewers Sara Barton (proprietor), Tom Coates and Alice Batham.

BREWSTERS

Brewsters began at Stathern in 1999 and moved to Grantham's Burnside industrial estate seven years later. The brains behind it is Sara Barton, a biochemist who completed a master's degree in brewing and worked for major brewers before setting up on her own, turning hops, barley, malt and water into real ale.

Now the workforce of five produce it in bottles, cans and kegs, as well as barrels. The microbrewery produces half a million pints a year, the favourite still being Hophead, a 3.5 per cent ABV golden hoppy beer.

In 2018, Sara won the All Party Parliamentary Brewer of the Year award for her contribution to the industry, having won the Guild of Beer Writers Brewer of Year 2012.

OLDERSHAW

Oldershaw Brewery began in 1996 by ex-Telecon engineer Gary and his wife, Diane, next to their home on the former Land Settlements, Harrowby.

Much of the equipment came from Shires Brewery in Bedfordshire and after trials the first beers were sold in January 1997 through the Chequers, Butchers Row. The first two beers to be marketed were First Edition (4.4 per cent ABV) and Liberation (4.7 per cent ABV). Later brews included Newton's Drop, Gravity Force and Old Boy.

Since then more than forty different beers have been produced and the 2,000th batch was produced in March 2011.

Kathy and Tim Britton took over in the summer of 2010 and, together with six staff, the brewery now produces about 250,000 pints of real ale a year at Barkston Heath, where they moved in 2013.

Heavenly Blonde is their bestselling beer.

NEWBY WYKE

Rob March was a home brewer before setting up commercially in a Calder Close garage in 1999. He named his brew Newby Wyke after the trawler skippered by his grandfather.

Launch of Newby Wyke Brewery at Man Loaded with Mischief pub, Aslackby. Shown are brewer Rob March (left) and landlord Steve Charlton.

With his wife Christine, he moved to a building behind the Willoughby Arms, Little Bytham, selling thirty barrels a week. In 2009 they settled at the current brewery on Alma Park. Their top selling brews remain Bear Island (4.6 per cent ABV) and Orsino (4 per cent ABV).

DOWN ON THE FARM

School holidays last as long as they do so that in the past children could help with the harvest. Until recent decades, many rural tasks were done by urban housewives, especially potato picking. They would be transported in the back of a pick-up truck to the fields and spend the day lifting them by hand. Their children often joined them, or went fruit picking.

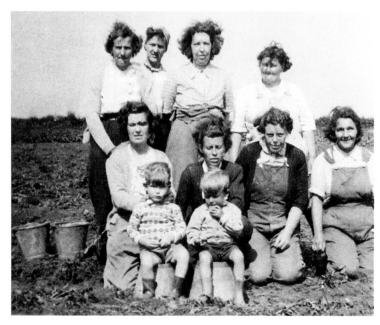

Potato picking at Long Bennington in 1947.

FURNITURE, FOOTWEAR AND FASHION

BJORLOWS

Nearly 500 jobs were created at Bjorlow (Great Britain) Ltd tannery when it opened on Earlesfield Lane in 1934. The Danish company had taken over the premises of Alexander Shaw, which had gone bust three years earlier after nearly seventy years.

Copenhagen-based Bjorlow Chromlaederfabrik had been exporting to the UK for years, but when the British government imposed import tax on all but Commonwealth goods, it moved to Britain to compete.

Much of the raw materials had to be imported, but fortunately the British Empire skins were quite suitable.

During the Second World War, with a depleted labour force, the company switched to making flying boots for RAF pilots.

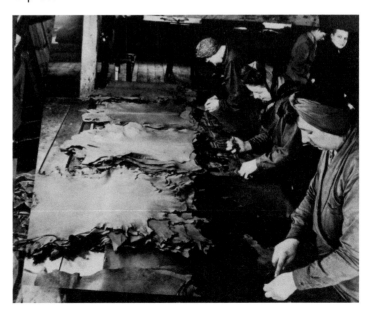

Bjorlows treating hides in 1966.

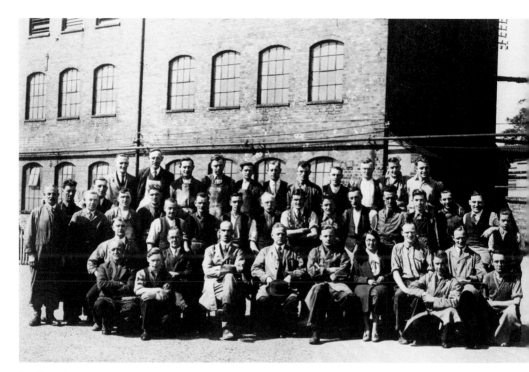

Staff at Bjorlows taken at Easter 1935, less than a year after the company opened in Grantham alongside the Grantham Canal on what is now Hollis Road.

Post-war production boomed and the works processed up to 15,000 skins a week, a logistical and cashflow problem, as there was several months delay from buying the skin to the finished product.

It developed suede that neither stained nor absorbed water and registered Shear-water and Ducksback trademarks. In 1969 it was bought out by Barrow, Hepburn and Gale, but four years later 180 employees lost their jobs when it closed.

ALEXANDER SHAW

Before Bjorlows, the tannery off Earlesfield Lane was owned from around 1860 by Alexander and John Shaw, who described themselves as 'Fellmongers, leather dressers and parchment manufacturers and makers of skivers, roans and basils, aprons, plasters and strains, sod oil and splits.'

BRITISH COROSIT BUTTON CO.

British Corosit Button Co. went bust in 1931, just two years after moving into the former Shaw's tannery (later Bjorlows). A creditors meeting was told it had cost £40,000 (£1.8 million in today's terms) to move to Grantham. When a £3,000 (£137,000) debenture was called in, there was no cash to pay it.

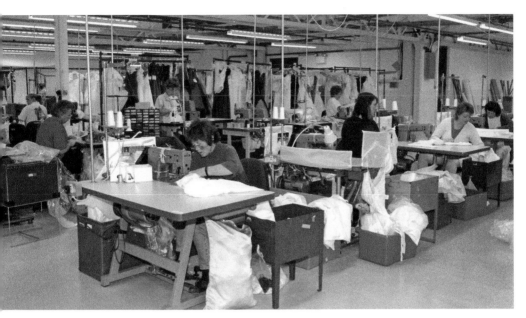

Bridal Fashions, aka Hilary Morgan, in 1997.

BRIDAL FASHIONS, HILARY MORGAN

Bridal Fashions opened its Grantham factory in 1970 in the former Ruston and Hornsby premises on Station Road East. It was run by Julian Lipman, whose family had a business in Lower Parliament Street, Nottingham. Originally called Lipman Bridal, it changed its name to Bridal Fashions three years later and branded its wholesale business Hilary Morgan after two directors.

By the 1980s it was the UK's biggest supplier of wedding dresses, with more than 700 outlets, many of them concessions in major stores under various names.

The two-storey building had its shortcomings and in 1997 the company moved to Springfield Park. It had a £20 million turnover at the time. Later that year it announced it would have to shed two-thirds of its workforce, amounting to some ninety jobs, blaming lower overseas production costs. It ceased production in 2004.

Hilary Morgan is now part of the David Keeling Associates group based on Swingbridge Road. It is a wholesale supplier of bridalwear manufactured in Vietnam and China.

SHADOWLINE FOUNDATIONS

Formed in 1965 by Frank Bolton and David Burnett, Shadowline Foundations began as brassier makers at a builders merchants alongside Harlaxton Road. Both had administrative experience at Welland Manufacturers on Dysart Road, which closed on the same day Shadowline opened.

The building was expanded to accommodate sixty people but was still too small, so they moved into a former maltings, adjacent to St John's Church, in 1971. It had three and a half storeys covering 22,000 square feet. They also had a smaller factory at Gainsborough.

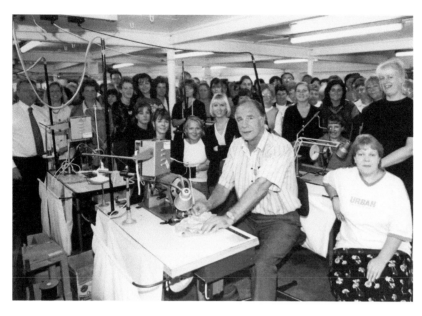

Retirement
of Frank
Bolton MD,
Shadowline
Foundations,
in 1999.

They expanded into all forms of underwear and swimwear and in the 1980s/90s had around 150 employees in Grantham.

The founders decided to retire in 1998 and sold it to Chillproof. Four years later, Shadowline went into receivership, shedding fifty jobs.

WITHAM CONTOURS

Witham Contours began in a small lingerie workshop off Springfield Road in 1976 before progressing to the former Reads Laundry building, Harlaxton Road, in the 1990s.

However, foreign competition forced the firm to close in 2003, despite having orders worth £400,000, with the loss of fifty jobs. The building was demolished to make way for a retail park.

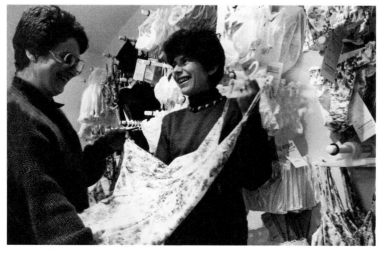

Witham Contours,
Harlaxton Road.
Val Butler (right)
is shown with
customer in
showroom in
November 1990.

Kemptons, Dysart Road, 1981.

T. W. KEMPTON

Knitwear firm T. W. Kempton moved into purpose-built premises, the most modern in the Midlands, on Dysart Road in 1975 with the promise of creating up to 250 jobs. The firm had arrived in Westgate premises in 1973 with twenty-four employees.

Reports in 1984 that the company was on the verge of closing and shedding 178 jobs were denied by managers, but it did close in February 1990, replaced by Grantham Bowl and the Fun Farm.

WOLSEY, WOLSEY LOMBARDI, COURTAULDS

Wolsey began in Grantham in 1961, in purpose-built premsies, at Gonerby Hill Foot. It made Jersey-wear garment ranges and was eventually taken over by Courtaulds.

Deputy Prime Minister George Brown visited the Wolsey factory to meet some of the 200 workforce in 1972.

Striking workers from Corthauld-owned Wolsey knitwear factory, in front of the Guildhall, as they stage industrial action in 1976 against threatened closure.

It was threatened with closure in 1976 but with backing of the Mayor Ivan Dawson, staff staged protests that led to a stay of execution. However, it was short-lived and was closed the following year with the loss of 164 jobs.

The premises were taken over by poultry processing company G. W. Padley.

GROSVENOR FURNITURE, QUALITY FURNITURE COMPANY

Formed in 1969 and moving to Alma Park five years later, Grosvenor Furniture began with seven staff. By 1983 it built a £750,000 factory on a 6.5-acre site at Alma Park, employing more than 300.

Grosvenor went into receivership in 1993 and its assets were taken over by the Quality Furniture Company, saving 200 jobs. A decade later it launched a new range of leather sofas and chairs, which saw an upturn in order volume. It had a £13.5 million turnover.

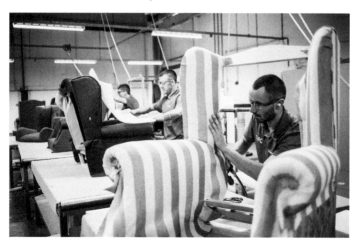

Grantham QFC furniture workers.

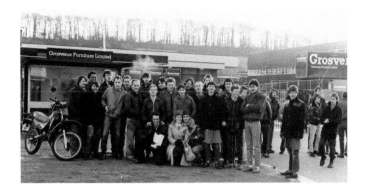

Workers at Grosvenor Furniture, Alma Park, walked out for a day in 1985 in a dispute over union recognition.

By 2008 it was one of only three suppliers in the country to be awarded platinum status by catalogue shop chain Argos after scoring top marks in a number of categories including quality of goods, communication and design.

However, ten years later joint administrators confirmed that the business would cease trading after failing to sell the company, with the loss of 160 jobs.

TODAY INTERIORS

Today Interiors was established as a family business by John Anderson at Gainsborough in the 1970s. The company quickly gained a reputation for innovative retail and contract fabric and wallpaper collections, which they distributed throughout the UK and Ireland.

It moved to purpose-designed premises on Hollis Road, Grantham, in 1981 and in-house design facilities were added. They then moved to Orchard Park, Alma Park, in 2012.

The design studio ceased and now around twenty-five employees import the finest fabrics and wall coverings and distribute them to boutiques and major stores including Liberty and Heals. Their products are often seen on TV and film sets.

The Today Interiors product range has been broadened in recent years to include plush high-performance velvet furnishing fabrics from Italy, weaves from Belgium, and designer wallpapers sourced in Europe and the United States.

More than half the staff have served between twenty and forty years.

Mike Burton in the fabric department of Today Interiors' warehouse, Hollis Road, in the 1990s.

MORE MANUFACTURERS

W. B. HARRISON

William Brewster Harrison, born in 1838, took over the family basketmaking business in Westgate, which employed two men and two boys, and grew it to set on more than 200 people.

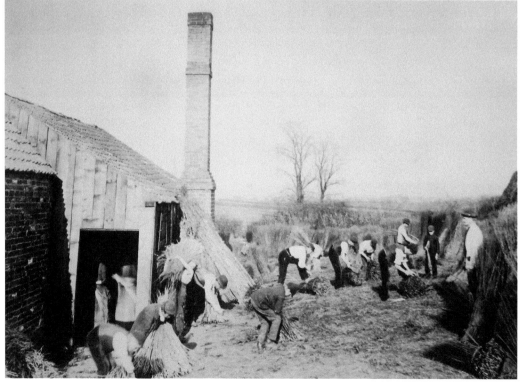

Harrisons Osier Works, Westbourne Place, off Dysart Road, in 1902.

His main factory, where the osiers (willows) were boiled to make them more subtle, was in Westbourne Place – also known as Rod Holt – although he had another factory in Union Street, as well as his shop in Watergate.

The range of goods was extended to other wicker products, made from the willows grown between the Grantham Canal and the Mowbeck and on marshy ground between Dysart Road and Barrowby Road.

He turned his attention to prams, wicker furniture and invalid carriages. The prams, which originally cost 4s (20p), were marketed under the Belvoir marque, which eventually became the Rolls-Royce of baby carriages. By the 1930s they were selling at £30 each – five times the wage of an average worker. They were made at the Wharf Road Factory (later the Tanvic site), formerly Boyall's carriage works.

Perhaps the most profitable side of the business was government contracts. The company supplied wicker baskets for both parcel post and to the War Office for carrying shells.

It was dangerous work. In winter the ice had to be broken on his garden pond to soak the osiers, while many workers were scalded in the open vats of boiling water used to soften the willow.

The Watergate shop, gardens and workshops were demolished in 1967 for Key Markets store and only the packing shop, now an antiques store in Union Street, remains.

VACU-LUG

Vacu-Lug was launched in 1950 by Lew Morley of North Road Tyresoles (services) at Great Ponton and Fred Widdowson.

The Vacu-Lug process incorporated various sectors of the industry – car, truck, tractor and earthmover – bringing these industries the most suitable tyres for their vehicle fleets.

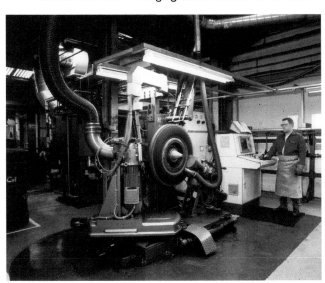 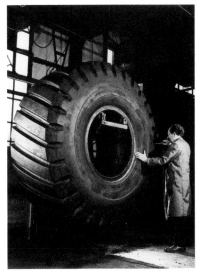

Above left: At the buffing stage of the truck tyre process at Vacu-Lug, 2018.

Above right: Examining the quality of the finished product (final inspection process) at Vacu-Lug, 1976.

It focussed on making its Duramold range of retread tyres more efficient at its plant on Gonerby Hill.

The following decade saw Vacu-Lug become Europe's largest independent tyre reprocessor with around 500 employees.

In 1974, it opened a smaller plant in Colsterworth specifically to focus on the production of its earthmover and tractor tyres. Although the production of car retread tyres had ceased, Vacu-Lug's production was unaffected and hit over 200,000 units a year for all products. It employed around 600 at the time.

In the 1980s new developments in tread design formed the backbone of Vacu-Lug's product range. Problems with the world economy encouraged Vacu-Lug to improve its UK sales and heading into the 1990s developed new techniques.

The millennium saw Vacu-Lug begin to further specialise its business as demand increased for fleet management packages that served all tyre requirements. It now has around 140 employees.

JOHN LEE (SACKS), S. G. BAKER, LC PACKAGING

John Lee as a company dates back to 1845 in Grantham, as specialists in skins, hair and feathers. The Welby Street depot saw rabbit pelts hanging up along Hands Yard, supplying hatmakers worldwide. By 1924 it was run by Rothwell Lee, who was also president of the Hatters' Fur Trade Federation.

John Lee (Sacks) was established in 1950 and took over the former Ruston and Hornsby blacksmith shop, which ran alongside Inner Street, concentrating on sacks and wipers. This was destroyed in one of Grantham's biggest blazes in 1960.

In 1970 it won a contract from the Royal Mint to supply 1.2 million sacks required to bag the new decimal coins.

The business, which supplies industrial and agricultural sacks, moved to Old Wharf Road after the fire, remaining there until it was taken over by S. G. Baker in 2006.

In January 2014, it became part of LC Packaging. It now specialises in flexible packaging and sandbags while Royal Mail continues to be a major customer. There are twenty-two employees.

Staff at John Lee Sacks, 1998.

Inside the Vale Garden Houses factory.

VALE GARDEN HOUSES

When Dennis Morton's wife wanted a greenhouse, he looked around and couldn't find one he liked, so designed his own. That was the start of one of Grantham's most successful companies.

At the time, Dennis was the owner of Marcus Designs, Bottesford, which reproduced small sculptures, but the distraction was too great. He bought the former motor repair workshop at Harlaxton and began to build made-to-order conservatories and within five years there were eleven employees.

The family business kept growing and in 2005 it moved to its current site on Londonthorpe Lane, with purpose-designed buildings incorporating a wartime shadow factory together with several units on Alma Park.

Now employing 200 plus, it not only builds high-end conservatories but bronze double-glazing units. Customers in recent years include the Bank of England, Windsor Castle, a number of celebrities, various universities and a 50-metre-long one in Eire.

BEAUMONT'S

Beaumont's Patent Firelighter factory was in Westbourne Place, off Dysart Road. It closed after the factory was gutted in a 1910 blaze. It had been there since Mowbray's Brewery moved to London Road some seventy years earlier.

ENVIRONCOM

Environcom arrived in Grantham from Scotland in 2007, on the back of a large local contract for processing Waste Electrical and Electronic Equipment (WEEE) following the introduction of the WEEE Directive. This required the producers or importers of the electrical waste to pay for a percentage of their equipment to be recycled.

It began at a former Aveling-Barford shop, off Houghton Road, but a major fire later that year forced them to move to new premises, the former Walkers Steel warehouse on Spittlegate Level.

The company gets electrical appliances from homes across the UK either by collecting on their own fleet of specialist vehicles from waste recycling centres, or delivered by national retailers who have collected the appliances when delivering new ones.

Each appliance is inspected for its reusability potential, repaired, tested, cleaned and sold where possible. All hazardous components are removed and all material which can be put back into manufacturing is recovered.

Full-time employees working at Grantham amount to 120.

Every week, Environcom in Grantham recycles in excess of 10,000 fridges. Less than 2 per cent of all the waste delivered into Grantham ends up in landfill. A total of 275,000 electrical appliances have been given a second life through its dedicated refurbishment workshop.

Above: Environcom plant at Spittlegate Level.

Left: Finishing staff clean up ovens and washing machines at Environcom before dispatch.

ROBINSON AND BARNSDALE

Cigar manufacturers Robinson and Barnsdale moved to the former prison, behind the Guildhall on St Peter's Hill, in 1882 on a seven-year lease. It employed 300 Grantham women.

The company moved out fifteen years later and returned to Nottingham as there was nowhere to expand. The building was taken over by the newly formed Grantham Technical Institute, forerunner of Grantham College. It was destroyed by fire in the 1920s.

FENCRAFT, BELL & WEBSTER, FP MCCANN

Fencraft set up on Gonerby Hill opposite Vacu-Lug in the 1950s, mainly casting concrete fencing.

It was taken over by Hertfordshire firm Bell & Webster in 1962, mainly casting concrete battery garages as well as fencing and retaining walls.

By 1988 the company had outgrown its premises and moved to Alma Park. It then employed twenty-four staff and cast 80 tons a day.

It became one of the UK's largest suppliers of precast retaining walls, used for applications as varied as earth retention to flood defence walls. It also provided terracing used in, among others, ABC, Odeon and Virgin cinemas and at The Valley, Stamford Bridge and Villa Park football grounds.

It was taken over by FP McCann in 2014, now employing up to 150 staff. The core products is flat-pack student accommodation for universities and hotels.

They also create L-shaped retaining walls for industrial and commercial use, precast panels for large warehouses and underground tanks.

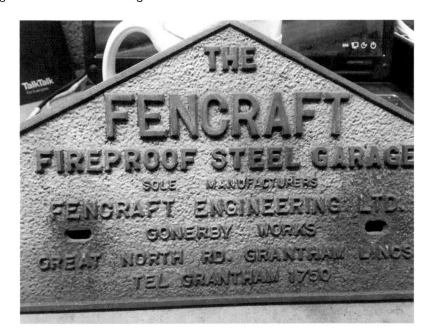

The nameplate for Fencraft, the origin of precast concrete in Grantham.

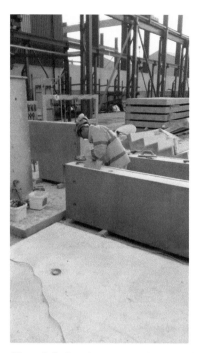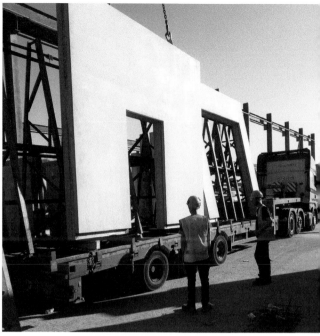

Above left: Producing panels at McCann in 2019.

Above right: Panels on their way from McCann in 2019.

HOLSCOT FLUOROPLASTICS

Holscot was formed in 1970 in the former Welby Street School, later moving to a former commercial garage at Harlaxton and finally to Alma Park in 1982, where twenty-five employees work. It was the brainchild of Dutchman Rene Kuyvenhoven and Scotsman

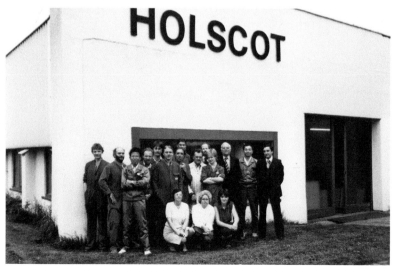

Holscot's Harlaxton factory with Japanese guests, *c.* 1983.

Richard Walker, who named it by combining abbreviations of their respective countries. In the beginning its major project was producing fuel bags for the MoD missile system.

Today, Holscot encompasses six divisions each specialising in specific areas of expertise, the HQ being in Grantham, which houses the main manufacturing area for the extrusion of high-performance fluoroplastics including tubes from 4 mm diameter to 400 mm.

It supplies non-stick roll covers for the paper, converting and reprographic industries. It also makes anti-moisture membranes for aero engines including Rolls-Royce, Pratt & Whitney and Honeywell.

The latest venture is an ETFE panel system for architectural and horticultural applications, such as greenhouses and a butterfly farm in Abu Dhabi. The system is lighter and stronger than glass as well as allowing more UV rays to pass.

The jewel in the crown was a five-year collaboration with Germany's MT Aerospace to develop and produce a lining system for tanks transporting drinking water to the International Space Station.

RERDS, AMERICAN CAN, NACANCO, PECHINEY, IMPRESS

The can-making factory was originally built as Reads in 1969 on the former railway marshalling yards, Springfield Road, mainly making cans for the pet food industry. It changed names as it changed ownership including American Can, Nacanco, Pechiney and closed as Impress in 2006. The factory was demolished the following year and the site developed for housing.

Impress Packaging as its future lay in doubt in 2004.

Impress Packaging in 2004.

UMBRELLA LTD

An umbrella factory became one of the first new businesses to set up in Grantham at the end of the Second World War. Owned by Kendall Ltd – nothing to do with the town MP Denis Kendall – it began with thirty women employed at the former Masonic Hall, over a London Road shop on the corner of Cambridge Street, in 1946.

It planned to open a new factory employing 150 as soon as possible but closed after eighteen years when production was transferred to the Leicester factory. Later that year, Grantham FC goalkeeper Brian 'Checky' Thompson opened his nightclub Rhythm and Blues Face Club at the premises.

BARRETT PACKAGING, MITCHELL & BARRETT, BARPAK, ARMOUR-BARPAK

It began with Barrett Packaging in March 1950, with five people working in the former First World War camp cinema. Ten years later, the Earl of Dundee formally opened a 110,000 square feet extension for 260 staff. By then it was the most modern, specialist packaging company in Europe.

However, in 1991 more than 100 workers were sent home amid fears their employer, Armour-Barpak, could fold. Share dealings in parent company Grovewood Securities were suspended as the price slumped to 2p and the company was wound up.

Internal shot of Armour-Barpak,
Alma Park, 1990.

MICROCAPTURE

MicroCapture is a small company with a big reputation. Founded and still run by Carol Brown in the early 1990s, it moved to the Grantham area in 2004, settling at Ellesmere Business Park in 2017.

Staff at Breaze
(Micro Capture), Swingbridge
Road, 2019.

The workforce of five enhance the fragrance of tissues including Kleenex and other papers using a blend of eucalyptus, menthol and camphor.

In 2018, they launched Breaze vapour oil, a range giving natural relief from allergies including hay fever, which can be used in various ways, including putting on pillows. The products are used worldwide including eucalyptus tissues exported to Australia.

GRANTHAM MANUFACTURING

Grantham Manufacturing hit the headlines in 1997 when it was instrumental in cutting down the noise at concerts. They developed a silent sweet wrapper for a cough lozenge company in conjunction with Radio 3. The sweets were given out free by the BBC at the Royal Festival Hall and the Edinburgh Festival.

The company is an independent paper packaging converter, manufacturing printed and/ or coated packaging products, mainly for the food, cosmetic and toiletry industries. It was founded by Reg Howitt, who in 1947 ran the area's first mobile fish and chip van. Then, in 1967 he began producing diecut shapes of silicone paper to interleave frozen burgers, in Inner Street. This led to Grantham Manufacturing.

He developed the production of gaskets for non-automotive applications and moved to Ruston Road. During the 1970s all Glow-worm boilers were fitted with gaskets made by GM.

In 1973 his son Colin joined the business and in 1977 his other son Martin joined, and it moved to the present Alma Park site.

However, in May 2015, a fire gutted the factory despite the efforts of six crews. Undaunted, the family rebuilt it, and not only is it 2.5 times bigger, it has geothermal heating (which involves water being passed 100 metres into the ground), solar panels and rainwater capture, making it one of Grantham's most eco-friendly buildings.

Grantham Manufacturing, Alma Park.

SERVICES AND CHARITIES

DUNCAN & TOPLIS

In 1925 two Nottingham-based chartered accountants, Stanley Duncan and Eric Toplis, decided to start their own practice. Opening in the city, they soon decided upon a second base in Grantham. The office was in Barclays Bank (now The Old Bank) Chambers.

In the late 1950s John Hindmarch joined and shortly after qualifying became a partner. He recruited his right-hand man, Keith Johnson, and by the late 1960s a period of rapid growth began. The office had employed around fifteen people.

They moved to No. 3 Castlegate and acquired Nos 4 and 5 shortly after, plus mergers with Baldock & Gregory, Bridger Wells & Co. and Coles Dicken & Hills.

More property acquisitions followed until the northern extent of the premises reached the Beehive Inn, adding the British Legion building in the early 2000s.

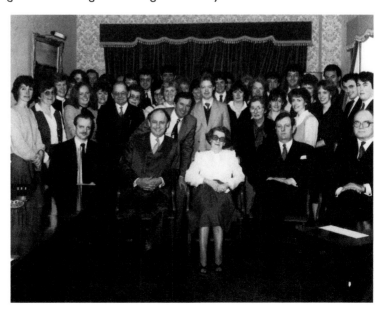

Duncan & Toplis' retirement, 1980s.

The business has expanded beyond pure accountancy and Castlegate Financial Management offers financial services and Datcom computer support services.

After John Hindmarch's retirement Peter Townsend headed up the business – one of a large number of King's School Old Boys to pass through. John, Peter and Keith each completed at least fifty years with the firm.

The partnership became a limited company in 2014 and now employs just under 400 staff, with seventy-four at Grantham for Duncan & Toplis, twenty-eight for Castlegate Financial Management and twenty-two for Datcom. It ranks as the thirtieth largest accountancy practice in the UK.

GRANTHAM GENERAL HOSPITAL

Grantham Hospital was officially opened by Lady Brownlow in 1876. The first big expansion came in 1935. Six new wards, each with a kitchen, a sisters' room and a room for a private nurse, were built. Being pre-NHS, the charge for each room was set at 75p per day or a subscription of £2.10 per year. Pay beds were also available in the children's ward at £3.15 per week. Medical fees were extra and by arrangement between the patient and doctor.

A £196,000 development of three wards, a new nurses' home, a boiler house and engineer's department were opened at Grantham Hospital in 1961.

In 1972, the new £440,000 three-storey maternity-gynaecology department opened with four-star hotel amenities. Originally, the department was designed to take forty-eight maternity cases plus ten cots for special care babies, but an unpredicted fall in the birth rate caused hospital bosses to cut this to thirty-six cases, making room for sixteen beds in the gynaecology unit.

Waiting lists reached critical levels in 1977 with more than 1,500 people awaiting inpatient treatment.

Another crisis loomed in 2016, when hospital bosses shut the night services for the Accident and Emergency Department. There were several marches, demonstrations at Westminster and a weekly night-time vigil by activists.

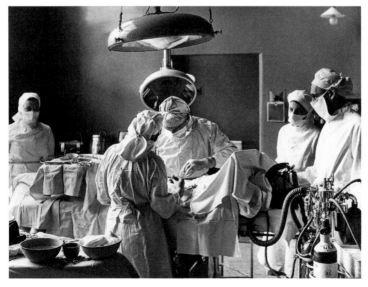

Registrar Mr O'Gara and Dr Campbell Holms at work in surgery in Grantham Hospital in 1949.

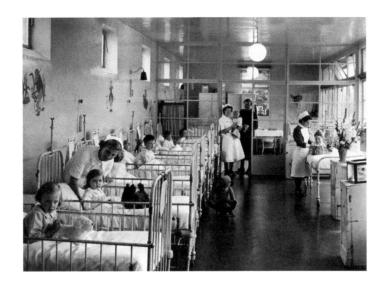

Children's Surgical
Ward, Grantham
Hospital, 1949.

In the year 2016/17, Grantham Hospital dealt with 14,465 inpatients, 88,344 outpatients, 24,800 were dealt with in A&E (accident & emergency) and 10,668 operations were carried out. The highest in any single day during the same period were eighty-two inpatients, 489 outpatients, 126 by A&E and thirty-three operations. The hospital has 128 beds (including twelve trolleys).

In January 2019, almost 900 people worked there, including 258 nursing and midwifery registered, 173 administrative staff and 108 cleaners, maintenance, catering and porters.

POLICE

Grantham's first professional police force began in February 1836 with four constables and a chief constable based at the Guildhall, Guildhall Street.

It was reorganised by the town council in 1857, headed by a superintendent, with two first-class constables earning £1 per week, three second class at 90p and one third class at 80p. The superintendent, on condition for his salary of £80 per year, also acted as inspector of weights and measures, nuisances and fire engines.

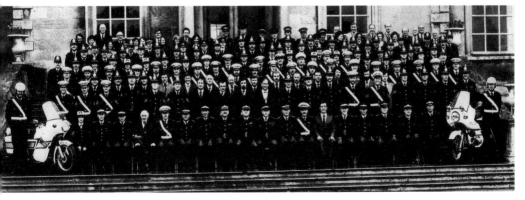

Grantham Police outside Belton House in Silver Jubillee Year, 1977.

When the borough boundaries were extended in 1879 Grantham and Spittlegate forces combined, bringing the strength up to three sergeants, ten constables and a chief constable.

In 1929 a new police station was built near the Guildhall.

Grantham Borough Police amalgamated with Lincolnshire Constabulary in 1947. They took over Stonebridge, St Catherine's Road, in 1959 until 2007 when they moved to a purpose-built £9.2 million home on Swingbridge Road.

At the start of 2019, 142 officers were stationed there, plus eleven PCSOs, twenty-eight civilians and eleven specials. They made 1,055 arrests in town during 2018.

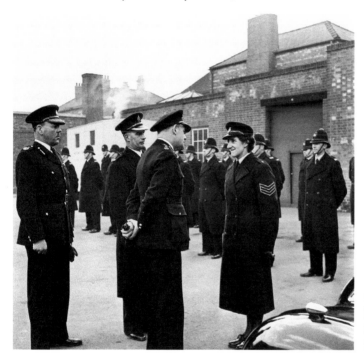

Grantham Police inspection with Sgt Dorothy Brook in 1955.

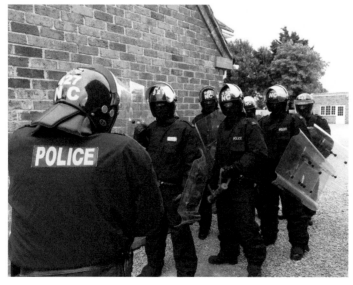

Armed police raid at Billingborough in 2017.

FIRE SERVICE

Grantham's first local volunteer fire brigade, based in the north porch of St Wulfram's Church, was formed in 1764 as a result of a major fire that had left up to 400 citizens homeless. Then in 1886 the fire station moved to the Guildhall and the borough council established the first volunteer brigade.

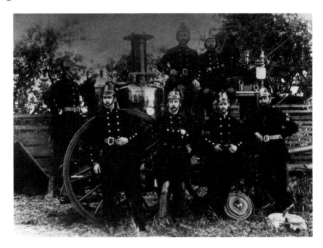

Ruston and Hornsby fire brigade, c. 1895.

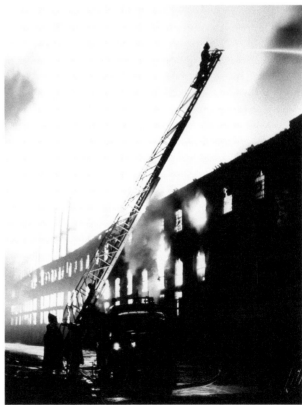

A firefighter tackles a £50,000 blaze at John Lee's, Inner Street, in 1960, the biggest fire in Grantham in living memory.

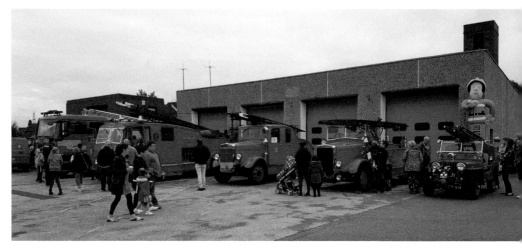

Good turnout for the open day at Grantham fire station, Harlaxton Road, 2018.

Horse-drawn steam pumps were finally replaced in 1925 to the self-contained units we have today.

The final move was to Harlaxton Road in 1946. The building was replaced on the same site in 1972.

In 2018, appliances from Grantham went out to 630 incidents, forty of them outside Lincolnshire. Of these, 203 were fire incidents.

There were ten wholetime and nine on-call firefighters based at Grantham in January 2019, with two fire engines, a rescue support unit and a high-volume pump unit.

GRANTHAM MERES LEISURE CENTRE

In 1963, the Grantham Memorial Pool Campaign announced it had raised £100,000 toward the target of £120,000 for an indoor Olympic-standard pool to include a 300-seat café. By 1967, the bill had risen to £180,000 and not a brick had been laid, but it finally opened in Union Street in 1971.

In 1982, the £1 million Grantham Leisure Centre attached to the swimming pool was opened by former England footballer Trevor Brooking.

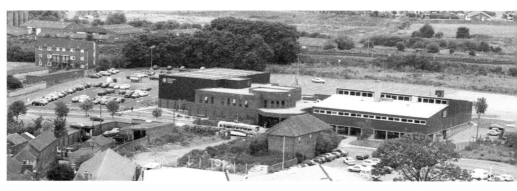

The original leisure centre in Union Street in 1989, demolished in 1995 for Asda.

Some of the
Meres Leisure
Centre staff
in 2019.

The main hall was big enough for four badminton courts and suitable for most indoor games including basketball and five-a-side football. It could accommodate 500 people dancing or 800 seated, while the smaller Witham Room could seat 360 people and be used for small sports.

A new £13 million stadium for Grantham FC and a leisure centre were planned by SKDC in 1989 on the 9-acre Meres recreation ground, Trent Road, but in November, the leisure centre plans were shelved, although the stadium went ahead.

Then in 1995, supermarket giant Asda made a £5.5 million bid to buy the Union Street leisure centre. The following year, £3 million from the National Lottery, plus the sale of the old leisure centre to Asda for a superstore, made the new complex on the Meres, off Trent Road, realistic and it opened in 1998.

Facilities include a seventy-station gym with around 2,000 members, four swimming pools, multiple sport halls including twelve badminton courts, football pitches, tennis court, spin studio with optional virtual classes, running track and 8-metre climbing wall. It is run by 1-Life.

Up to 150 staff work there, of which about a quarter are full time and twenty are qualified lifeguards.

MARK BATES

Mark Bates, now based at Londonthorpe Road, supplies a range of specialist insurance schemes, primarily to the disabled and over fifties market but are branching out into the more general insurance market.

The eponinous Mark, and Simon Oakes, started the business in Mark's garage in 1997, with taped-up doors to keep out the draught. The following year they took an office in Westgate, then moved to an office next to the Squash Club, Harlaxton Road, from 2002 to 2015.

The company now employs more than seventy staff and writes nearly £15 million of insurance premiums per year.

Telesales department at Mark Bates Ltd in 2019.

WOODLAND TRUST

The Woodland Trust was set up in Devon by Kenneth Watkins in 1972. Concerned small broad-leaved woods, spinneys and copses were disappearing, he set up the Woodland Trust with three close friends. The first woods acquired were in the Avon Valley and soon the trust owned over 40 hectares there.

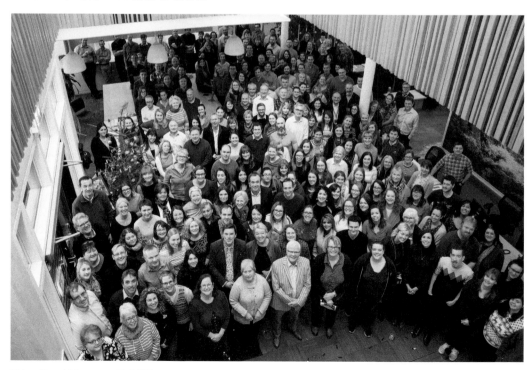

Woodland Trust staff, 2018.

The trust became UK wide in 1978, and the headquarters moved from Ken's kitchen table to Wide Westgate, Grantham, then to the former Coles Cranes offices, Autumn Park, in 1985.

In 2010 it moved to purpose-built £5.1 million headquarters off Dysart Road, said to be one of the most environmentally friendly buildings in the UK. The 29,000-square-foot office was built using timber.

It is estimated the carbon saved by not using a concrete frame was equivalent to the first nine years' running costs and was hailed as one of Europe's leading examples of eco-friendly office space.

With 300 of its 500 employees in Grantham, it is one of the town's major employers. The organisation has more than 1,000 sites, covering 22,500 hectares (56,000 acres), in its care including Londonthorpe Woods. It is responsible for planting more than 42 million trees nationwide.

SOUTH KESTEVEN DISTRICT COUNCIL

South Kesteven District Council (SKDC) was formed in 1974 from the boroughs of Grantham and Stamford, Bourne Urban District, South Kesteven Rural District and West Kesteven Rural District.

Covering 365 square miles, its four customer services centres handled over 200,000 inquiries in 2018. Employing 608 staff, 183 of them manual roles, the council owns and manages 6,000 council homes. It collects 53.000 tons of domestic refuse and recycling from the 65,000 households annually.

The council-run biennial Gravity Fields Festival generated an estimated £930,000 economic benefit to the Grantham area in 2018.

SKDC's new offices and council chamber under construction in 1986.

POST OFFICE, ROYAL MAIL, POST OFFICE TELEPHONES

The first post office in Grantham was at the Angel Hotel from around 1690. It moved by 1826 to Market Place, although in 1893 a health inspector visiting the premises said it was in an unsanitary, rat-infested condition, so it moved across the road.

It moved again in 1922 to specially built premises on St Peter's Hill. This was replaced by a modern building in 1969.

The old sorting office, a former 1917 army hut, was also replaced and a new entrance to the sorting office opened on Wharf Road. The post office closed in 2019, moving into WHSmiths, High Street.

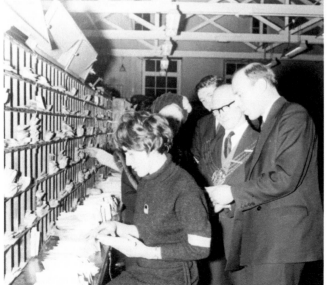

Above: The old post office before it was demolished in 1969.

Left: The mayor and mayoress, Councillor and Mrs Herbert Harris, visit Grantham sorting office just before Christmas in 1964.

In 2010, Royal Mail Grantham's 120 staff handled 24 million letters and 2 million packets. Nameplates were installed on all streets and all houses numbered in 1871 to help postmen with deliveries, but due to rapid developments many streets had to be renumbered in 1914. It was 1885 by the time the first telephone was installed in Grantham, and by 1901 there were only thirty-three subscribers in town, although the council agreed to spend £2,000 on

Above: Inside Grantham sorting office, 1988.

Right: Grantham Telephone Exchange at the post office.

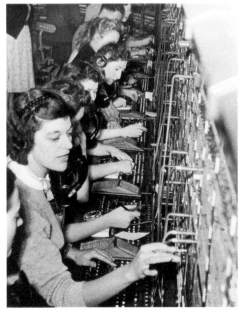

a telephone exchange in Market Place, which would link up with the National Telephone Company in the belief this could reach eighty.

Cables were overhead until 1923 when Post Office Telephones began to lay its town centre cables underground. Connections were still by operators, who worked at the General Post Office, St Peter's Hill. It reached bursting point as subscribers reached 2,250. In 1964 a new exchange was built in Inner Street for the introduction of STD (Subscriber Trunk Dialing).

However, as more and more automation was introduced, manual work declined and in 1992 the telephone exchange closed and work transferred to Peterborough. The building is now used by telephone engineers.

THE RAILWAYS

For more than a century railway companies were major employers in Grantham.

The Ambergate Railway from Nottingham to Grantham was the first in 1850, followed two years later by Great Northern Railway.

The Peterborough to London section of what we now call the East Coast Main Line (ECML) opened in 1850, and the next stretch, including Grantham, was to employ more than a thousand navvies.

At Ponton, short cuttings and banks through rocky strata were followed by low-lying land over the Saltersford area where the Witham was crossed by a bridge before the line entered an unstable shale area under Spittlegate Hill.

After passing under the main road, the land levelled out until it was to cross Grantham Grange district on an embankment where the station was planned, and then on through Great Gonerby to the tunnel. At their height, in April 1851, the workforce included

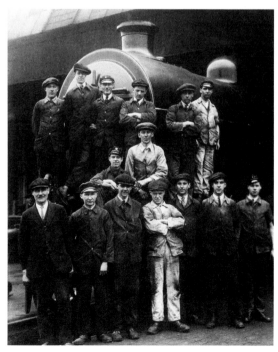

Cleaners beside the Ivatt Atlantic locomotive in 1922

1,479 labourers, seventy-five miners, thirty-four blacksmiths, thirteen horse-keepers, fifty-seven brickmakers, thirty-eight bricklayers and seventeen brick labourers.

Grantham became the first stop for main line expresses from London, gradually ousting Peterborough as an engine changing post, partly as a result of the various branch lines that converged near to Grantham. This led to many jobs from cleaning to maintenance. By 1880 it was a major locomotive changing place and junction.

Steam locomotives, which had run through Grantham for more than a century, were taken out of commission in 1963 to be replaced by diesel-powered units, which drastically reduced the number of maintenance staff. These in turn were replaced in 1988 after the first electric train ran from Grantham to King's Cross in October.

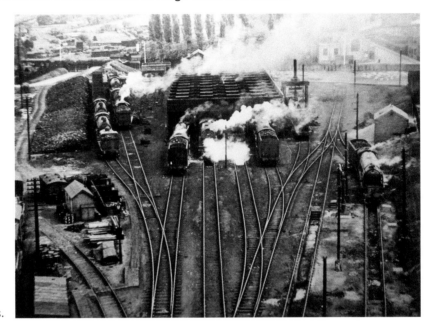

Railway marshalling yards near Springfield Road, 1950s.

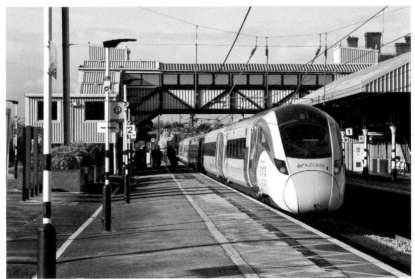

The Azuma at Grantham station, November 2017.

A test run on the Electra train the previous day clocked at 145 mph. This was followed two years later by the closure of Grantham's train crew depot after 138 years, which had once employed 500 men. Six signal boxes also disappeared, replaced by a push button-control centre in Yorkshire.

TREASURE TRANSPORT SERVICES, J. O. TREASURE, GRANTHAM ROAD SERVICES

Treasure Transport Services Ltd (TTS), Gonerby Moor, is the product of the merger of Grantham Road Services Ltd (GRS) and J. O. Treasure Ltd (JOT).

GRS was incorporated in 1954 to acquire the assets of the Harlaxton Road depot of British Road Services following the denationalisation of the road haulage industry.

The share capital was acquired by Gary Greenhalgh in 1997, who closed the Harlaxton Road depot but continued to operate as a general haulier. The old depot was taken over by James Irlam until it moved to Worksop in 2005.

JOT was incorporated at a similar time and was a specialist bulk liquid operation servicing the dairy and brewing industries.

In 2002 the two businesses were merged. GRS purchased the assets of its subsidiary and changed its name to Treasure Transport Services (TTS). In 2005 the two business activities moved to the purpose built 6-acre site at Gonerby Moor, where around seventy people now work.

In 2007, TTS became members of Palletline. The company now operates four main divisions: Food-grade Bulk Liquid Distribution, General Distribution, Palletline and Tank Washing

Dedicated beer tankers transport from the breweries to bottling plants if the brewery does not have its own facilities. They also cover one-off events such as festivals like Glastonbury, Isle of Wight, etc., as well as Winter Wonderland in Hyde Park and the Cheltenham Gold Cup, delivering lager and cider, and, in some cases, leaving the trailer unit behind which is connected directly to the beer pumps.

Above left: A Grantham Road Services lorry prepares to take scouts in the Barford's Gala parade in 1972, from the Harlaxton Road depot.

Above right: A real treasure – one big beer can.

WHAT'S IN STORE

WATKINS

A lodger over butcher Joseph Fowler's Westgate shop in 1912 took over the business, which is now not only one of the town's longest-running family businesses, but also the most popular.

By the 1950s, William Watkin's sons, Louis and Philip, had taken over in Westgate and London Road respectively. Their sons, in turn, Graham and Pip each opened an extra shop, in Market Place and High Street, although in 1990 Graham moved out of the trade to concentrate on his venture the Red Lion pub at Newton.

A decade later, Pip bought the former Record Shop, next door in Wide Westgate, to expand, closing the Market Place shop. The shop, which opens daily from 5 a.m. to 5 p.m., employs around thirty staff.

Each week Watkins create 6,800 sausage rolls. They also make 16,300 (3,300 lbs) sausages weekly, and a year's production, laid end to end, would stretch from Westgate to Nottingham city centre, with a few to spare.

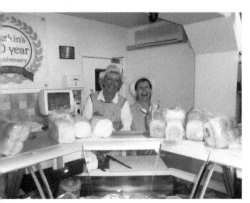

Above left: Linda and Lorraine at Watkins butchers, 2019.

Above right: The butchers and bakers who prepare the food at Watkins.

Inside the Asda supermarket in August 1998, three months before opening. Its 45,000 square feet would make it the biggest supermarket in town.

ASDA

ASDA opened its superstore in 1998, but not without controversy. There had been a three-year battle against conservationists and sportsmen who insisted they wanted the leisure centre to remain in Union Street and not be rebuilt at the Meres.

When it finally opened there were no problems getting a labour force with more than 2,000 people applying for the 330 jobs.

Two of the national company's Chief Executive Officers, Andy Clarke and Andy Bond, were local lads, both ex-King's School.

D. E. CHANDLER

It began with William Coultas, who, aged twenty-one, bought Nos 91 and 92 Westgate to open an ironmongery, selling the range products the family firm was making at the Wharf Road and Station Road (West) factories.

The shop was subsequently taken over by Barker Bros, followed by Des Chandler in 1935, who developed it into a store that sold everything from a 'panel pin to a combine harvester'.

In 1944 it became a limited company with Tom Caunt and Joe Pell as directors taking over when Des left to concentrate on his hatchery business in 1959.

When Chandlers closed the shop in the 1990s, it was taken over by Fabric Warehouse, which in turn closed in 2014. It then became a gymnasium.

D. E. Chandler of Westgate in 1984.

Radio presenter David Hamilton with Lyons Maids at Tesco, St Peter's Hill, in 1970.

TESCO

Tesco moved into St Peter's Hill, Grantham, in 1962, becoming the town's first supermarket. It was built on the site of the Picture House cinema.

It shut in 1985 with the loss forty-five jobs, following the building of Morrisons far bigger store nearby.

The store was taken over by Bejam and then Iceland. A decade later, there was further development when it was demolished and twelve new shops incorporated into the Isacc Newton Centre were built in its place,

SLATER AND PADGET

Gunsmith George Slater and cloth finisher Thomas Padget came to Grantham from Wakefield in 1861, taking over the business of Herbert King at No. 55 High Street (renumbered as 59 in 1869), whose father, Samuel King, had run the business from 1831 to 1857.

Slater and Padget opened as wholesale and retail general ironmongers, gunmakers, nail makers, smiths, tinmen and braziers.

Thomas Slater took over on his father's demise in 1903 until his own death in 1926 when the business ceased. The shop portion was taken over as an extension to R. Garratt & Co., Waterloo House, while the upstairs rooms became extra bedrooms as part of the George Hotel.

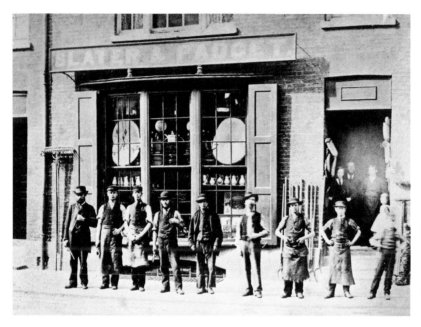

Slater and Padget's ironmongers shop on the High Street in the 1860s.

HOMEBASE, MATALAN, TK MAXX AND CURRYS

Homebase came to Grantham in 2005 as part of a development on the former Corus steel warehouse, Dysart Road. There is a 300-space car park on the Matalan, TK Maxx, Homebase – and later Currys – site with the building behind. The two main units cover 82,000 square feet and 60,000 square feet of its retail space. Homebase closed in 2019.

Homebase, Dysart Road, October 2018.

COLLARDS

Henry Collard took over the business of Henry W. Henley of No. 12 Watergate in July 1896, acquiring No. 13 Watergate for expansion in 1942. It was an ironmongers and gunsmiths.

George Willoughby opened No. 2 Westgate in 1901 when the iconic 'Little Dustpan' sign is thought to have been erected. Collards took over the business in July 1938.

Both shops closed 1982 following the retirement of owner Ray Tuxworth, who had joined as a shop assistant in 1935, when he was unable to sell the business.

Five years later, the Watergate premises reopened as the Gatehouse pub and later the Playhouse.

Right: Collards ironmongers, Watergate, taken in 1948.

Below: Collards, aka the Little Dustpan, in Westgate, just before it closed in 1982.

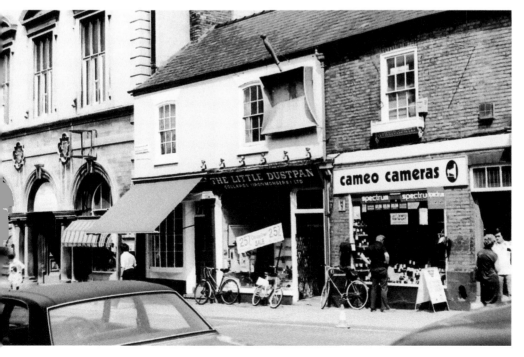

Dean Law, manager of M&S Food, together with all the staff at the store opening on London Road, Grantham, in November 2014.

MARKS & SPENCER

The Midland Bank, High Street, was pulled down together with Foster's tobacconist in 1933. In their place, national clothing store Marks & Spencer built a new store, where nothing cost more than 25p. The store closed in 2011, although the company opened an M&S Food store on London Road in November 2014.

WHIPPLES

Whipples opened its Watergate haberdashery business in around 1882 and was one of the largest in town. Then in 1906, George Whipple opened a garage (later Lloyds pharmacy) opposite the George Hotel to cater for the new, expanding interest in motor cars. It had a showroom upstairs.

In June 1916, the drapery was destroyed in a mystery £15,000 blaze. Looking to the future, Whipple rebuilt a garage on the Watergate site in 1920, set back from the road to allow forecourt parking.

At nearly 200 metres long, it was then the biggest garage workshop in the eastern counties, able to store 300 cars. It closed in 1986 and was taken over by exhaust and tyre specialists Kwik Fit.

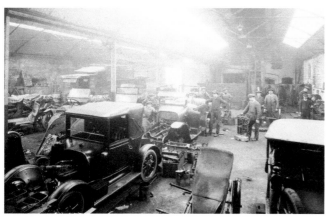

Inside Whipples Garage in around 1920.

Rebuilding Lidl supermarket, 2015, with St Wulfram's spire under repair in the background.

KEY MARKETS, GATEWAY, LIDL

Old buildings on the west side of Watergate, including a former Co-op store, were demolished in the 1960s and replaced by Key Markets supermarket, the first in town to have its own parking.

The store opened in March 1973, but two weeks later closed following a fire, which destroyed the cashier's office, telephones, overhead wiring and two-thirds of the wines and spirits department.

The store, later renamed Gateway Supermarket, closed in 2000, with the loss of twenty-seven jobs, two years after Asda opened next door. The premises were taken over by German chain Lidl and later rebuilt, completed in April 2015. The store employs forty full- and part-time employees.

LIPTON'S

Before the day of the supermarkets, Grantham had a number of provision merchants including Lipton's, which had opened in Grantham in 1908. It closed in 1982, putting eighteen out of work, blaming rising overheads.

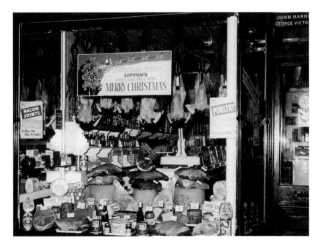

Meat, poultry, fruit and vegetables were all sold fresh and displayed in 1958 at Lipton's High Street store.

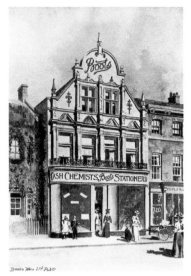 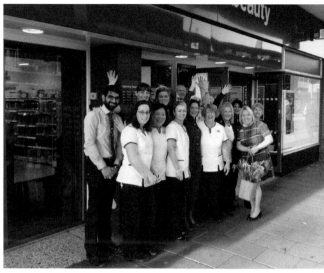

Above left: Boots store, purpose-built in 1899.

Above right: Boots staff, High Street, Grantham, following a major revamp in November 2015.

BOOTS

When Boots Cash Chemists opened at No. 14 Market Place in February 1892, it became the first Grantham shop where you wouldn't be served by the person whose name was over the door. They opened their purpose-built High Street shop (now Halifax) in 1898, as the old one became rat-infested.

There they remained until 1965, when they took over the store built by Fine Fare three years earlier on the site of the Horse & Jockey pub, High Street, where forty-seven people are now employed. Boots also closed its London Road branch in the move.

JOHN PORTER & SONS

John Porter bowed out of business life when he sold his High Street shoe shop in 1985. The Porter family began their shoe business in Elmer Street (north) in 1829, when John Porter from Fulbeck set up his business near the Angel & Royal courtyard. Three generations later, by 1890, ready-made shoes were appearing along with bespoke ones.

In May 1912, they took over No. 33 High Street and in January 1963 moved to much larger premises a few doors down at Nos 38/39. The shop was then run by John and his daughters Jane and Sarah.

OLDRIDS, DOWNTOWN

Oldrids were established at Boston in 1804, but it wasn't until 1989 that they decided to build the store at Gonerby Moor. This proved to be a big success and in 2000 TV gardener

Above left: Winter sales at Porters Shoe shop, High Street, in 1963.

Above right: Downtown furniture department, 2018.

Below: Downtown garden centre, 2018.

Charlie Dimmock opened the East Midlands biggest garden centre at the site, creating traffic jams on the A1.

It currently employs 260 people, but plans are in hand for a super retail park to complement the present businesses. Its two cafes are also very popular, selling more than 23,832 lasagnes and 57,492 pots of tea each year.

BOUNDARY MILL

Boundary Mill moved into Grantham in 1996 and is regarded as one of the area's main tourist attractions. It is one of five stores owned by the family-run business.

Boundary Mill, 2019.

In 2018, 420 coaches brought 14,500 customers to the Gonerby Moor store for a day out – and that's on top of the 1,000s who drive there each week.

Around 250 people work in the retail designer discount store, of which around 80 per cent are employed by franchisees. One of them, Pavers, sells around 54,860 pairs of shoes a year at the store.

MORRISONS

The £10 million Isaac Newton Centre shopping complex opened on St Peter's Hill in 1984, centred around Morrison's supermarket, taking two years to build almost to the day. The development caused the demolition of hundreds of premises in Stanton and Rutland streets, together with much of Welby Street and the northern side of Wharf Road.

The supermarket created 257 jobs – but applicants were told they were not allowed to bear tattoos on display.

SAFEWAY, SAINSBURY'S

Grantham's major football and cricket clubs were forced to leave their London Road ground in 1989 after nearly a century, when Buckminster Estates sold the land to build Safeway supermarket.

Grantham CC moved to a new home on Gorse Lane, while Grantham Town had to play their home games at Spalding until the Meres Stadium was ready.

In 2004, it was taken over by Morrisons, who were already established in the town, but owing to takeover regulations was one of fourteen stores it was forced to resell to Sainsburys in a £300 million deal, who still operate the store.

Above: Morrisons opening in 1984.

Below: Safeway, London Road, under construction in 1991. It later changed to Sainsbury's.

OTHER EMPLOYMENT

GRANTHAM BOOK SERVICES

Originally called Chatto, Bodley Head and Cape Services, Grantham Book Services opened at Alma Park in 1975, when Labour leader Michael Foot planted a Canadian maple tree in the grounds. It is now one of the biggest book distributors in the UK.

The company was given its present name in 1989 and three years later became the first to be awarded Distributor of the Year at the British Book Awards.

Having acquired eight other units around the town, it consolidated in 2008 when it moved to its current Trent Road site, previously a distribution store for pet foods. This has 334,000 square feet, the equivalent of nine football pitches, to store 29.2 million books. These include 64,000 titles from forty-six publishers – the biggest being Faber, Lonely Planet and Bonnier.

Each week, the 150-plus workforce ships out 900,000 books across the country, although in a single day, following Black Friday in November 2017, they moved out 1.4 million.

And just to show their green credentials, they have two very active beehives on site.

Grantham Books, Alma Park, in 1992.

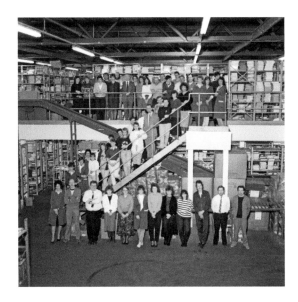

Grantham Books, Trent Road, 2018.

READS LAUNDRY

Reads had begun in Vine Street in 1859 before moving to purpose-built premises on Harlaxton Road in 1947. It remained in the Read family until 1977 when it was sold to Jackson's Laundry of Lincoln, which continued to trade as Read's and Derek Mitcham remained manager. It closed around ten years later and the building was taken over by Witham Contours.

FENLAND LAUNDRY, GRANTHAM STEAM LAUNDRY

Fenland Laundry opened on Swingbridge Road in 1989, but its history goes back much further. It began 111 years earlier on Belton Lane as Grantham Steam Laundry.

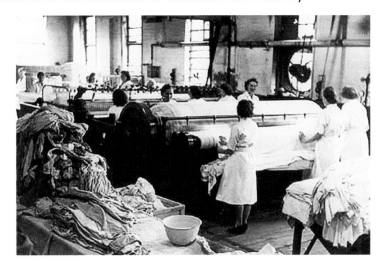

Grantham Steam Laundry in around 1950. The rollers are giant mangles.

The Victorian building was one of the first to be built on Belton Lane and was gas powered until 1917, when electricity was installed.

Originally, most of the work was for the public, although the thirty staff at the Swingbridge Road factory now specialise in protective clothing for both the industrial and pharmaceutical markets.

In 1918, GSL was fined 10s (50p) for allowing women to work on a Sunday, despite the company claiming the women were being patriotic as they were doing work for the army.

BELVOIR!

Belvoir Property was set up by Wing Commander Mike and Stephanie Goddard in 1995 at Hawthorpe, near Irnham, mainly as agents between property owners and tenants. They took over the former courthouse, London Road, in 1999 for its national HQ, where it remains.

Belvoir! has 170 locally managed offices, running more than 30,000 properties – with a total value of over £10 billion.

In 2012, Belvoir! became the first residential lettings agency to launch on the AIM of the London Stock Exchange.

CHANTRY DANCE COMPANY

Chantry Dance Company is a professional UK touring contemporary ballet company formed at Sadler's Wells in 2012 by choreographers Rae Piper and Grantham-born Paul Chantry. Both had enjoyed stellar performance careers in London's West End, at the Royal Opera House, Sadler's Wells Theatre and internationally, and now work as choreographers and movement directors who have choreographed shows in the West End, the UK and internationally.

Artistic directors of Chantry Dance Company, Rae Piper and Paul Chantry, alongside the assistant director, David Beer. (Dani Bower)

The husband and wife team choreographed the Olivier-nominated West End production of David Walliams' *Gangsta Granny* as well as some of the *Horrible Histories* stage shows. They moved to Grantham in 2013 to bring professional dance performance and education.

Each season the company rehearses for around two to three months in Grantham to create an original ballet, written by the company, before premiering at the Guildhall Arts Centre, then touring the UK. The company hires around six to nine professional dancers each season and company members have included Dominic North (Principal with Matthew Bourne's *New Adventures*), Shannon Parker (Principal with San Francisco Ballet and Northern Ballet Theatre), and Alessia Lugoboni (Royal New Zealand Ballet). All the dancers live locally during the rehearsal periods.

The company started Chantry School of Contemporary & Balletic Arts and an Outreach Department to develop the next generation of dancers.

Chantry enjoys an excellent relationship with neighbours DancePointe, a local dance school run by Principal Rosie Toulmin-Rothe. Some of the Chantry faculty are also affiliated teachers at DancePointe, supporting the young dancers of Grantham even further.

Successes at major national and international competitions include All England Dance Finals – Ballet & Contemporary Young Dancer of the Year Winner; Winter Festival Art Studio Danza – Ballet & Contemporary Overall Winner; Youth America Grand Prix – New York Finalist; ABT & Bolshoi Scholarship Winner; and ISTD Bursary Awards – Contrasting Solo Winner

Chantry Dance Company now has an international presence and has been invited on numerous occasions to work in Italy, creating choreography for vocational dance students there and adjudicating international competitions.

TOTEMIC, PAY PLAN

Totemic Ltd was formed in 1993 by Philip Rann and Lianne Tapson as a financial services and corporate lending business, which has now evolved into a group of companies, providing payment solutions, debt management, insurance and lending. There are currently 700 people employed at the company, mainly on Springfield Park and Kempton Way. As well as offices in Grantham, Totemic also has sites in Nottingham, Lisbon and Malta.

GRANTHAM JOURNAL

The *Grantham Journal of Useful, Instructive and Entertaining Knowledge and Monthly Advertiser* was launched in February 1854. It cost one penny (0.4p).

The man behind it was bookseller John Rogers, head of Rogers & Son in Walkergate (Watergate). The monthly paper had only four pages (a folded sheet), with only national news and local advertisements.

The following month, the front page was totally advertising, and it was 1941 before news appeared on the front page again.

The *Journal* was a success and after four months the broadsheet was selling 1,600 copies and by the end of the year 2,000, with twelve pages. It became a weekly and soon had the second largest circulation of newspapers published in Lincolnshire.

In 1862, the paper was bought by Henry Escritt, co-founder of estate agents Escritt and Barrell. Members of the Escritt family served as directors for the next fifty years.

Reporter Brenda Welbourne and her colleagues celebrate her fortieth year at the *Journal* in 1986.

In 1866, the *Journal* moved to the former Mail Hotel, High Street, which it occupied until the noughties. In the early days, plates containing national news were set in London, delivered first by stagecoach, then by rail. Local pages were set by *Journal* staff.

At the turn of the twentieth century the print room employed a dozen men. Printing the paper began at lunchtime on Friday and continued until the early hours of Saturday morning. The paper was printed by hot metal process at the *Journal*'s High Street works until 1973.

The *Journal* remained a family company until 1984, when it was bought by Grantham shopper owners EMAP and became a tabloid the following year. Reporters used typewriters until 1989 when the company introduced computers and desktop publishing.

In the 2010s the office moved from High Street, first to St Peter's Hill then back to Watergate, where it had all begun.

GRANTHAM GUARDIAN

Dissatisfied with the support he lacked from the *Journal*, Grantham MP Denis Kendall decided to launch his own newspaper, the *Grantham Guardian*, in 1945. Its offices were on the College Street corner of London Road, with the printing works in Bath Street, behind the State cinema.

It folded in 1950 after Mr Kendall lost his seat in the general election.

GRANTHAM SHOPPER

The free newspaper, which also had Melton Mowbray and Syston (Leics) editions, was launched by John Bradshaw in 1973 in Butchers Row, with his other enterprise, Bradleigh Estates. It moved to the top floor of Watergate House where up to ten people worked – mostly advertising staff. Printing was at Horncastle.

It was bought by the EMAP group, who in 1985 also bought the *Journal* and merged them. It was renamed *Journal Extra*, followed by *Leader* and finally *Citizen* before being withdrawn.

Grantham Shopper's tenth anniversary.

GRANTHAM & MELTON POST/TRADER

A free newspaper, the *Grantham & Melton Post* was launched in 1984 from offices in Welby Street and lasted until 2000. It changed to *Grantham & Melton Trader* in 1989.

STANBOROUGH PRESS

The Stanborough Press Ltd, the official publisher for the Seventh-day Adventist Church in the British Isles, began in 1894 at Holloway Road, London.

The press continued at Watford, through both the Depression years and those of the Second World War. Then in January 1964, its facilities were ravaged by a fire that 'reduced the despatch department, the art department, the editorial department, the chapel and the paper store to ashes'.

When the new Stanborough Press building was officially opened in September 1966 it was at Alma Park, Grantham. The church had decided, for various sound reasons, to decentralise its publishing and printing activities to Lincolnshire, where commercial property was much cheaper and housing for the staff more affordable.

The next major change was the decision to close the production unit from June 2002 to make Stanborough Press a publisher, with printing and binding outsourced.

Stanborough currently markets a wide range of products in the UK, Ireland, North America, Mexico, the Caribbean, Africa and the adjacent Indian Ocean islands, Australia, parts of Europe and Asia. It now employs around twenty-three staff, compared to a peak of nearly sixty in its printing days.

Left: Stanborough Press staff, Alma Park, in 1980.

Below: Stanborough Press at the opening in 1967.

EGB (ESCRITT, BARRELL & GOLDING)

Escritt & Barrell was founded in 1861 by Henry Escritt, who also owned and ran the *Grantham Journal*. He started Grantham Cattle Market in 1871, which continued until its demise in 2001. He took C. F. Barrell as his partner in 1897 and founded Grantham Horse Sales, which ran until the 1930s.

The firm amalgamated with Golding in the early 2000s and now operates its estate agency, agricultural, urban professional and management business from No. 24 St Peter's Hill.

Escritt & Barrell's cattle market in 1918.

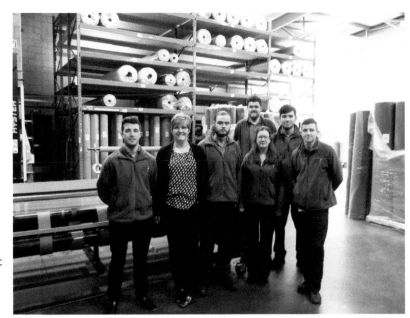

Staff and management at AT Industries, Springfield Park, in 2019.

AT INDUSTRIES

AT Industries began above a Grantham High Street betting shop in 1994, acting as a third party for the import and export of automotive textiles (hence the name) and exhibition flooring. It began with two or three employees and has grown to fifteen at its Springfield Park base.

Most of the business is still the supply of textiles and vinyl flooring for vehicle interiors but includes hard-wearing entrance matting, exhibition carpets for temporary events and artificial grass for landscaping.

Carpets have been supplied for the 2012 London Olympics, Glasgow 2014 Commonwealth Games, after parties at the Brit Awards and private bashes for both Ant & Dec and Frank Lampard.

The Springfield Park warehouse stocks 6,250 rolls of material, a total of 340,000 square metres.

EDDISON PLANT

Starting as Eddison Steam Rolling at Dorchester in the 1860s, it was taken over by Edward Barford shortly after the war to give Aveling-Barford products more exposure. It had depots across the UK, and it opened another at Belton in 1947, which later became Chandlers.

New offices were built for the HQ in Harlaxton Road in 1965, with a huge depot behind. Until the 1960s, their road rollers, towing a green caravan and green tank were a familiar sight. Then over the years roller hire was replaced by forklift truck hire.

They moved from Harlaxton Road to smaller premises on Spittlegate Level in 1994, when the offices were reoccupied by the magistrates' court. It was taken over by Yale and the Grantham depot closed shortly afterwards.

The iconic vans towed by Eddison steam rollers.

FOSTERS BUILDERS

W. Foster originated in Newark in the 1920s from a long-time family of bricklayers. They moved to Grantham, opening a yard and offices in Castlegate, before moving to Wharf Road when they took over Rudd & Sons yard. Fosters Builders then became a partnership of Rudd & Sons and Foster and Rudd.

During the Second World War they constructed a number of factory buildings for the Ministry of Aircraft Production around the town. They also built offices for BMARCo and Neals (later Coles) Cranes.

By 1960, they had built 834 council houses for Grantham Town Council and West Kesteven RDC. They also completed three new wards at Grantham Hospital. A further 394 private

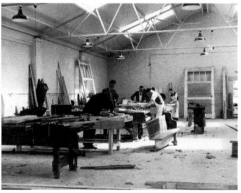

Above left: Foster's joinery workshop, Wharf Road, in around 1960.

Above right: The houses forming a crescent around the oak tree on Belton Lane were built in 1948 by apprentices. It was the team's second project after building four houses in Sharpe Road. From the back left are George Kirton (instructor), Ginger Jessop, S. Pearce, Noel Wallis, P. Clark, Stan Wade, Gordon Porter and Jack Cornall (instructor); Calcraft, Eric George, Ben Hardy, John (Cassy) Brown and Barrie Roberts are in the front row.

Longcliffe Road
built by Fosters
in 1963.

homes were built in the same period, in the Denton Avenue area (following the insolvency of Hunt Lea Estates), Lime Grove and Somerby Hill, as well as Balderton, Spalding and Bourne. At one time it was one of the biggest building firms in the East Midlands.

In the 1960s saw its biggest development: the Manthorpe estate. All windows were made by the company's joiners at the Wharf Road workshops. On average the company employed 350 tradesmen, including forty on maintenance. The company went bust in 1981 with debts of £346,000.

INSTITUTE OF MATERIALS, MINERALS AND MINING

The Boilerhouse, the delightfully quirky building on Caunt Way, proves modern offices do not have to be boring. Based in the building that once generated the power for BMARCo, it was reclad and refurbished by the Institute of Materials, Minerals and Mining, who in 2009 became the occupants.

The design reflects the site's industrial use in the past and this theme continues inside. It is used as a conference, training and exhibition centre. It is also a showcase for the latest material technologies that have been used in the construction and refurbishment of the building. A staff of fifteen work in the building, which houses an impressive archive of materials, minerals and mining.

The Old Boiler
House, home
to Institute of
Materials, Minerals
and Mining.

Staff at Khaos Control in 2019.

KHAOS CONTROL SOLUTIONS

Khaos Control Solutions employs fifty staff at its Caunt Road premises, making software that helps businesses manage their stock control and sell in markets like eBay.

It was founded in 2000 by Mike Cockfield, writing business software for what were then mail-order companies. Today those businesses are called multichannel retailers, as they tend to sell their goods via many different sales channels, which include catalogue, physical shop, their website, on the telephone and marketplaces such as Amazon and eBay.

They now supply software tools to control their day-to-day operations, aiding stock control, warehouse management, sales order processing, supply chain management, the handling of promotions and sending data to external courier systems, among much else.

Khaos Control Cloud and Khaos Control Web are later creations.

BRISTOWES TARVIA, COLAS

Road repair specialists Bristowes Tarvia began at the Old Wharf in the 1920s, making its own emulsion from bitumen before taking it out to surface roads. At the time it was a by-product of the nearby gasworks.

A Bristowes Tarvia truck resurfacing a road in Oxfordshire. On the tarbar is Harry Wright of Grantham, who worked there for twenty-eight years.

The company was taken over by Colas in around 1980, and within ten years was using emulsion made at a central factory in Warrington.

Although the company used to employ mainly local people, most of the 160 people based at the Dysart Road depot live away and are sent directly to the sites.

ROCKET PRINT & PROMOTIONS

After working on exhibitions for ten years, Noel Reeves decided in 2009 to start his own business from home, organising stands for local business.

Most of the work was outsourced until 2013 when Rocket moved to Inner Street. Here, they began building the stands and printing the 3.2-metre-wide posters.

In 2017 they expanded to Ellesmere Business Park, with a staff of twenty. The majority of the exhibitions are in London, shared equally between NEC, Olympia and XL, amounting to around 75 per cent in total.

The remaining quarter is in the UK and Europe, although they have also sent their products to USA and Australia.

Making an exhibition: staff at Rocket in 2019.

Some of the staff at Rocket, March 2019.

ACKNOWLEDGEMENTS

The author would like to thank all the people and organisations that made this book possible, either indirectly or supplying information and illustrations. They include Bruce Adams, Jim Allen, Anthony Bailey, Sara Barton, Malcolm Baxter, David Bell, Molly Bingham, Frank Bolton, Roy Bradley, Carol Brown, Bob Brownlow, George Burdett, Chloe Butterick, Reg Carrington, Paul Clark, Derek Clarke, Mike Cockfield, Barrie Cox, Judy Dexter, Robin Dickinson, Paul Dodd, Darren Eaton, John Foster, Steve Foster, Wendy and Neil Fraser, Simon Goldstein, *Grantham Journal*, Grantham Library, Grantham Museum, Marie Hall, Vaughan Hardy, Thomas Hathaway, Alastair Hawken, Elize Hibbert, Alan Hodgson, Paul Jackson, Mark Jennings, Paul Johnson, Ruth Jowett, David Keeling, David Kettle, Malcolm G. Knapp, Neil Lamont, Tom Lee, Walter Lee, Peter Levs, Elessa Maelzer, Marianne Marshall, Stan Matthews, Brian Moreland, Lisa Morton, Keith Noble, Simon Oakes, Ian 'Pugsy' Parker, Sam Pask, Paddy Perry, Noel Reeves, Emma Roberts, Andrew Robinson, Allan Senior, Angela Shields, Hannah Shipman, Sleaford Library, Dee Smith, John Smith, Cris Stephenson, David Sykes, Kate Taylor, Jill Tittensor, Peter Townsend, Trish Walker, Stuart Watts, Brian Wright, Gerald Wright, John Wright and Spencer Wright. My apologies to anyone accidently omitted from the above.